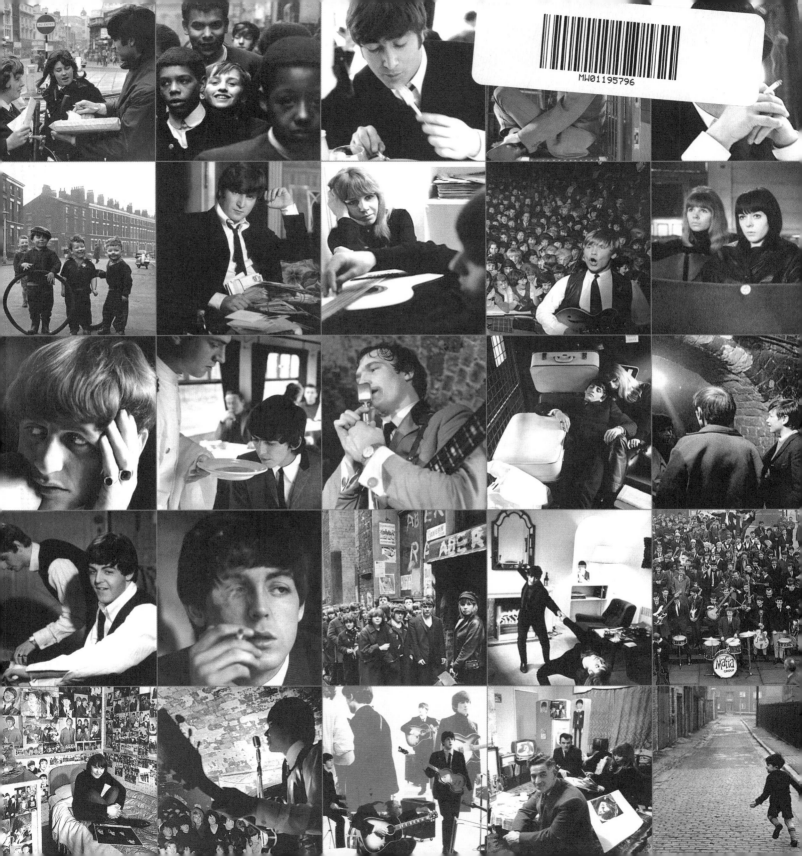

MW01195796

YESTERDAY

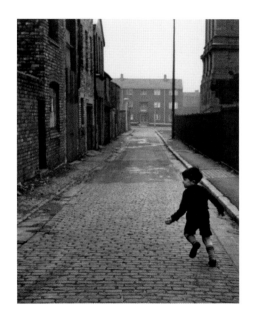

The Beatles
Once Upon A Time

YESTERDAY

The Beatles Once Upon A Time

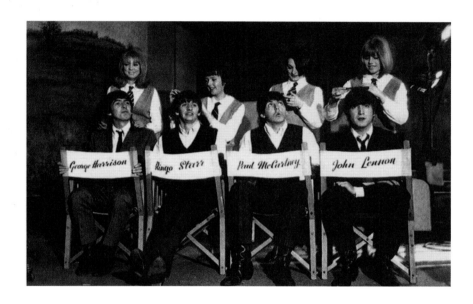

ASTRID KIRCHHERR

MAX SCHELER

THE VENDOME PRESS

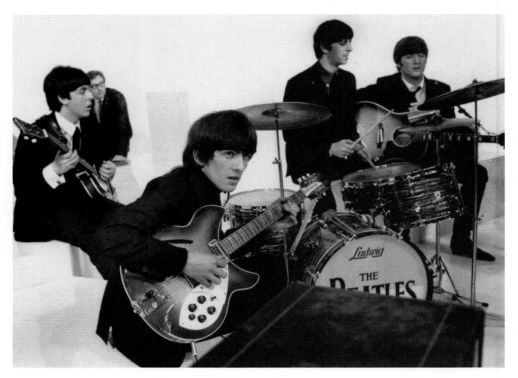

Yesterday: The Beatles Once Upon A Time originally published as two signed, limited editions, produced by
Genesis Publications Ltd, Genesis House, 2 Jenner Road, Guildford, Surrey, England, GU1 3PL
Liverpool Days designed by Wherefore Art? and *Golden Dreams* designed by Genesis Publications Ltd
Editorial by Alex Hedley and Bruce Hopkins

www.genesis-publications.com

First published in the United States of America by
The Vendome Press, 1334 York Avenue, New York, N.Y. 10021

Library of Congress Cataloging-in-Publication Data
Kirchherr, Astrid.
Yesterday: The Beatles Once Upon A Time / by Astrid Kirchherr & Max Scheler. — 1st ed.
176 p. 24 cm.
Text and photographs by Kirchherr and Scheler. Includes bibliographical references (p. 4,5) and index.
ISBN 978-0-86565-189-0 (hardcover: alk. paper)
1. Beatles. 2. Beatles—Pictorial works. 3. Rock musicians—England—Liverpool—Biography. 4. Rock
musicians—England—London—Biography. 5. Music—England—Liverpool—20th century—History
and criticism. I. Scheler, Max. II. Title.
ML421.B4K57 2007 782.42166092'2—dc22 [B] 2007016890

Printed in Singapore

PUBLISHER'S NOTE

The photography of Astrid Kirchherr and Max Scheler was originally published by Genesis Publications Ltd in two limited edition books. The first, *Liverpool Days*, published in 1994, the second *Golden Dreams*, published in 1996. The following text is Brian Roylance's original publisher's note from *Liverpool Days*.

"I would like to thank my good friend Ulf Kruger for introducing me to this project in the first place and for his enthusiastic involvement all along the way. I should also like to thank Astrid and Max for their great photographs and help. As always Kay Williams' editorial skills have been invaluable while Ulf and I are both grateful to Kai-Uwe Franz for making such fine prints from Max's and Astrid's negatives.

Thanks also to Wherefore Art? for strong layouts, weak tea and some weird music.

Finally I would like to thank everyone, famous and unfamous, who appears within these pages without whom this book would not be possible."

INTRODUCTION BY ASTRID KIRCHHERR

The following photographs were taken in the spring of 1964. It is a time which will always belong to The Beatles – then at the very peak of their popularity – as well as to the beautiful Liverpool, whose life and fortune was also changing as a result of the success of its favourite group.

In February of that year, whilst The Beatles were making history in America on *The Ed Sullivan Show* and their latest single 'I Want To Hold Your Hand' was playing on radio stations all around the world, I was working in Hamburg as assistant to the photographer Reinhart Wolf. I met Max Scheler through Reinhart and one day Max asked me if I would like to help him. He was engaged in writing an article on The Beatles. Knowing that I was pretty close to them, Max asked me to join him and to introduce him to The Beatles; to act as a 'door opener' for him. In addition, he knew that I was a friend of many other musicians whom I had met at the Kaiserkeller, the Top Ten and the Star Club. Of course I called The Beatles to tell them about Max's offer, and George said, 'Well, as long as they pay you good money to do it, it's all right with us.' So I agreed.

No other journalists were allowed near The Beatles at this time. They were so busy that Brian Epstein had ruled that they should not be bothered by the press. So Max and I were very lucky: we were allowed to stay on hand with the boys all over the set of *A Hard Day's Night* for the several days we were there. They treated me as they always had, like an old friend, and they were very good to Max as well.

I had befriended and first photographed The Beatles when I met them three years before in a little Hamburg club. I'd been drawn then by the magnetism that had, by 1964, captured the rest of the world. I hadn't been looking to make my reputation through their stardom – they had none. I had fallen in love with their attitude and their faces; theirs was the look I had wanted to photograph.

The Beatles hadn't changed from when I first met them – they were always the same. What had changed by 1964 was their lack of freedom. All of them, but especially John, found it very difficult being cooped up in a flat or a car or a TV studio every day. When I had known them in Germany, they were an adventurous lot, always running about, doing exactly as they liked. Now they were too busy, too popular, unable to go anywhere without constant media and fan attention.

They had money – that was new – but they couldn't spend it. I remember George sending me to the shop to get him some records. It was madness – they couldn't even pop out for a pint of milk. And unlike today, when rock stars have events and their daily movements organised for them, The Beatles looked after themselves – all they had was Brian's office in London, Neil Aspinall (their roadie) and the lovely Mal Evans.

We started in London, joining The Beatles making *A Hard Day's Night*. The train in which they were filming was running non-stop, so if one of the boys was not working, he would get rather bored. During their breaks we would spend time with those not being filmed, investigating each and every corner of the train, joking around and taking photographs.

In London I stayed at Ringo and George's Green Street flat. We had a great time, on and off set, and they introduced me to lots of people – those who had access to them, it was hard for them to see anybody, really. They worked hard every day filming and had to be up early each morning, so we didn't go out in the evenings. They didn't have the time.

The boys would learn their lines in the car on the way to the set, or between shoots. They were still young and irreverent, and they didn't take it all that seriously. They certainly weren't thinking in terms of acting

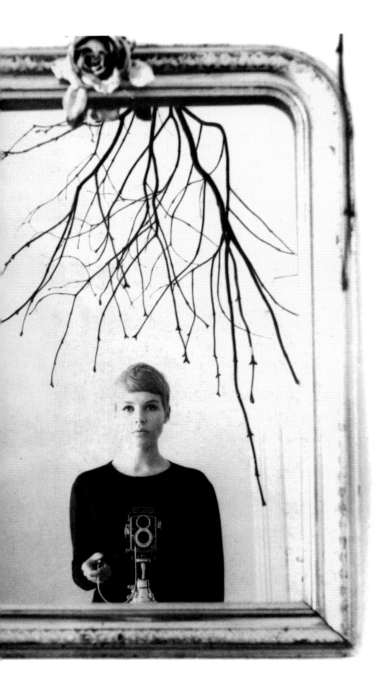

careers, so their performances didn't worry them too much. It was a laugh, as it always had been. They would lark about on set and it was a very familiar atmosphere. John would be cracking jokes and Richard Lester would sometimes collapse with laughter. At the same time, they were professionals and when it came to the scenes, they knew their lines. It wasn't chaos, but it was very friendly and many jokes were shared by them and Dick Lester. He was very pleased with how they worked with him. And of course, Brian Epstein, a lovely man. I knew Brian, and we liked each other very much, although we were not as close friends as George and myself.

I remember in the train sequence of the movie were two young actresses playing schoolgirls, one with short dark hair and one with blonde. I think it was my first day on the set; we were in one of the carriages and these two girls, quite in awe of The Beatles and very happy to be there, stood about constantly looking at the four guys and giggling. George would look over discreetly at them, kick me and point out the blonde one: 'Doesn't she look great? Just like Brigitte Bardot.' He fancied Pattie straight away, though he played it so cool at first – the sly thing. I don't think he said a word to her that day!

That was the first time I met Pattie Boyd, who George later married. Cynthia, who was also around, I had known almost as long as the boys themselves. When she first came over to visit them in Hamburg, she had stayed at my flat because the boys' place then was so squalid.

Max and I also visited The Beatles' homes. John wouldn't have Max come over to his place – it was not for the press – but he invited me over. He and Cynthia were in a flat that had been rented for them by Brian. They had moved into it furnished, which explains those horrible curtains in my photo! I remember they were keen to move out and get their own place, as soon as they had the time.

George and Ringo were sharing a flat. We sat around, talking about music whilst Max took his photographs.

Ringo asked me if I knew a certain dance but I did not, so he said, 'Come here and I'll demonstrate,' and he did. Ringo was into dancing, more so than the others, and was really very good and Max, of course, was delighted with the photographic opportunities.

After staying with the boys, we went to Liverpool. I always preferred Liverpool to London. Although the people were very poor and run-down there, everybody was always so friendly and good to me.

The first time I'd been to Liverpool was in 1961. What I remember most then were lots of gangs and fights and rough areas. The Liverpudlians had always been so very friendly, but they were also very sad about their lives and opportunities. One of the greatest things I noticed about Liverpool this time was all the energy and excitement that The Beatles had created. That's one of the things that I am most proud of them for. I saw a great difference in the optimism of the people, especially the young folk. All of a sudden Liverpool was on the map and success was something they could understand. On every street corner were groups of young boys strumming away at their guitars, or they were peering into Frank Hessy's shop window. Everyone was much more positive, everyone was dreaming.

I revisited the Cavern, of course. There were so many bands playing now. There were the big Liverpool groups like Rory Storm & The Hurricanes, The Merseybeats and others that I knew. (They'd often come to play at the Star-Club or the Kaiserkeller. There was a lot of interchange: the Hamburg band The Rattles came over to Liverpool as Germany's answer to The Beatles – of course they weren't, but they were very good.) And at lunch times there were competitions for unknown groups – groups like Arrow & The Archers that I made particular friends with – who would go up on stage with their guitars and play, judged by the audience's applause.

Then, as now, I found the people of Liverpool warm and friendly as nowhere else I've been, always joking and having fun, no matter what their lives. A lovely place.

We met Ringo again in Liverpool. I'd already met Maureen. Ringo had been going out with her since before he moved to London. She was great, a really nice Liverpudlian woman, always really funny and lively, with a great sense of humour. Ringo would often go home to see his parents and Maureen. He went back to Liverpool more than the others. Max also wanted to go and, since Ringo was going anyway, he was happy to have Max come along.

We went to see George's parents, too. I had known them for quite a while. They were two wonderful people who had always treated me very kindly. When I phoned them, they were very excited about meeting us. Even when they heard it was an interview for a magazine, we were still welcome.

Whilst Max was organising the big photo session at St George's Hall I took a walk on my own, and that was when I saw those four kids who appear on page 68. I was fascinated by the appearance of the children and the poor, run-down neighbourhood in which they lived. Two of them were standing in the middle of the road talking to their friends, and I asked them to join together in a group. They asked me what I wanted and I told them that I wished to photograph them. 'Great, great, great!' they yelled, 'She's going to take our picture.' I told them, 'Just stand there and don't move,' and they obeyed and that was it. The one with the cap was very much like John, in his whole manner and in the way he spoke to the others, I knew at once that he was the leader of the gang.

For me the trip, especially the Liverpool part, was very exciting. Not only was I seeing new things, but I was working with a miniature camera for the first time and Max was encouraging me, giving me all the confidence I needed.

Photography enables you to experience events more intensely and thus we gained a fuller understanding of the whole situation, of what was happening inside and outside the Cavern. We saw all those kids queuing up for lunchtime sessions, all the faces, trying to be individuals at any price. Faces and expressions are observed more clearly through the lens of a camera. It was an impressive experience.

I constantly tried to imagine how the five Beatles would have been when they were 12 or 14, because so many of those little faces and the behaviour of the kids reminded me so much of them. The whole atmosphere of the place was incredible – the squalid and depressed city full of these wonderful people – I have seldom met so many lovely people as kind and friendly as they were.

Associating the fame and fortune of The Beatles with their origins is a difficult task. After being in London, and witnessing the fever of the Beatlemania which existed there, and then going to their home town and seeing that there was nothing there except all those quite poor, young people with such expressive faces, was an experience of startling contrasts.

The photographs which Max shot in Liverpool, especially the ones at the Cavern, are for me a brilliant document of those days. They exist as a piece of contemporary history, for he managed to capture the spirit of that time.

INTRODUCTION BY MAX SCHELER

In 1964 I was a photographer for *Stern* in Hamburg, running around the world, covering political and social events, such as the aftermath of President Kennedy's assassination in the United States, the war of the French in Indochina, Mr Khrushchev's travels through Western Europe and the unrest in the Middle East. I considered myself a serious photo-journalist. The lighter side of the world was not in my line of work. However, one day my editors asked me to go to Liverpool, to check out what it was that had triggered the phenomenon called Beatlemania, which had conquered the world that year.

I was not exactly square, but still, I wondered whether if at the age of 35, I could dive into that scene. And then I remembered Astrid, the pretty assistant of my photographer friend Reinhart Wolf; Astrid Kirchherr, who had been so closely attached to The Beatles during their Hamburg days, having been engaged to one of them, washing their socks and underwear, and also having taken their pictures which were later to become famous. Astrid agreed to help me and came along, and opened up the way for me.

Our first stop was to be London, with the gods themselves. I remember feeling self-conscious when I first saw Astrid at Hamburg airport. She was dressed in tight leather jeans and jacket, wearing an Iron Cross medal which, when we arrived at Heathrow, the immigration officer viewed with suspicion. We were picked up by a smart Bentley and its elegant chauffeur which George and Ringo had sent to take us to their flat in Mayfair, where Astrid was going to stay for a couple of days.

The boys were quite busy, shooting their first film, *A Hard Day's Night*. Astrid and I watched the proceedings at the studio and also travelled on the train where part of the film was set. In between shooting there was plenty of time to relax and chat. I liked George and Paul best; they were the most approachable, but Astrid was close to all of them and was having a good time. Once in a while the train would stop and hysterical girls would be waiting at stations, pressing their faces against the windows, begging for autographs. At night, we relaxed at the flat, George would play some chords on his guitar and Ringo and Astrid would dance to it together.

I had hoped that I could persuade the boys to go with us to Liverpool, but the film schedule did not allow for it, and finally only Ringo came along, just for a few hours to see his mother and stepfather, who lived in a small terraced

house in Dingle, not the smartest part of town. They were sweet to us. Ringo had offered them a new house somewhere else, but they insisted on staying where they were because they loved their neighbours. Ringo fell onto the sofa and we could tell he was happy to be home for an hour or so at least. The place was pretty much run-down; only a collection of gold and silver records showed a glimpse of the glamour that now surrounded the son of the house.

Astrid and I also saw George's parents, who had moved to a better location near Woolton. Brother Pete, working as an auto mechanic, had exchanged his motorbike for a Hillman sports car and brother Harold had just been given George's cast-off Jaguar. The Harrisons, who had been living on six pounds a week until recently, were looking forward to their first trip to Jamaica: a present from George.

Just for a short time I saw Jim McCartney, who was living in a middle-class house which looked pretty messy. I suppose it was because he was a widower. He moved the dirty laundry from the table and offered us an Irish coffee, then proudly showed us his own fan mail and lots of tobacco and pipes from girls who hoped he could get them an autograph from Paul.

With Ringo gone, Astrid and I were on our own. The city looked pretty depressing to me. It reminded me of Germany after the war, whole sections seemed to be still in ruins, and it was in such a neighbourhood that Astrid took the picture of the four little street kids, which I feel is the strongest image out of all the pictures we shot whilst in Liverpool. Then we discovered Arrow & The Archers. Twelve-year-old Les Cartlidge was one of the Archers, playing the guitar which his mother had bought for him; the others, David (Arrow), Mike and John, had only sticks to drum on a trash can. To me those pictures were the most typical of the story, kids who enjoyed their music so much in the midst of all that rubble. They later performed for us at home, their parents proudly listening to their shouts of, 'Wanna be your baby!' The next day, Arrow & The Archers had their first gig at the Cavern Club, the inner sanctum of Beatlemania.

I remember that Mathew Street was lined with warehouses and tall walls whose bricks had become discoloured by the black smoke of industry. I think that we arrived there around three-thirty in the afternoon. There was a crowd of sombrely dressed kids, aged between about 12 and 15, more girls than boys, although we could not really tell. Most of the girls were wearing long black coats or skirts. All of the boys had the mop haircut, which had not yet arrived in Hamburg, although I know that Astrid had invented it for Stuart and George. All of the boys wore tight trousers with chains above tall-heeled boots. Some even had ties or school scarves around their necks. They were queuing in a fairly civilised manner, although not all of them looked that way. Some of the girls, especially, tried to look nasty, wearing heavy make-up under their innocent eyes or even adventurous eye-patches. They were trying to look much older than their age but some looked as if they had escaped from Oliver Twist's workhouse.

The Cavern Club opened at four in the afternoon for the junior session. Bob Wooler, the compere, a softly spoken middle-aged bachelor, opened the doors himself. You had to step down into the cellar and the place resembled a dungeon. One story I was told about the club was that it had been built by slave traders, who built it solidly so that no disturbing noise from the slaves' chains could be heard up in the street. It only took minutes until our friends Arrow & The Archers started their music, and although they only had small amplifiers

it shook me and everybody else right to the bone. The girls were looking up at the band full of adoration, as if worshipping in front of an altar. There was none of the frenzy that characterised The Beatles' performances wherever they now appeared. In the back, a whole row of very young couples were kissing; however, to me it seemed like a ritual rather than a display of affection, as was the pretentious act of smoking. They were trying to behave in a shocking way and they thought they were being grown up. They all seemed to have a lot of fun, and Astrid and I enjoyed it tremendously.

There were about 400 groups in Liverpool at the time. Some were doing quite well. One such group was The Merseybeats, who still behaved and dressed quite rowdily, and went running around the streets, although they were already earning 10,000 pounds a month. There were others, like The Escorts, with their smart manager, Jim Ireland, a former butcher; and The Undertakers, whom I photographed at St George's Cemetery under the old cathedral with their coffin, in which they carried their instruments. Some of them played at the Cavern, others at the Iron Door Club, which belonged to Les Ackerley, who alone had 20 groups under contract and who also exploited Beatlemania with his factory that produced plastic Beatle heads.

At the centre of the action was a music store belonging to Frank Hessy, who sold about 90% of his guitars on an instalment basis. Outside, the store was always besieged by kids, flattening their noses against the shop windows, craving the great selection of red and white guitars with their chrome fittings, ranging from between 30 and 500 pounds each. Hessy confessed that he thanked God every night for creating The Beatles, and that he treated any tatty little boy as if he were a potential Beatle.

At the end of my visit I planned to assemble a group of kids with guitars together, on the steps of St George's Hall in Liverpool, in order to get a good picture for my story. I had organised a cherry picker (mobile platform) to get a good overview. I put a note on the board at Frank Hessy's and an advertisement in the local paper promising one pound for any boy who would come along with his instrument to this location at noon on Saturday. About 350 boys did show up, and Astrid and I had a hard time bringing the crowd under control and making sure that each of them received his promised fee.

My Merseyside stay was a great experience. I particularly enjoyed the warmth and sweetness of the people there, especially amongst the young. I did not know much about music, but I learned that the power of The Beatles' sound and of those young aspiring musicians remaining in this city of high unemployment, had released a lot of the frustrations and tensions that had been bottled up within the youth there. Beforehand, the youth crime rate in Liverpool had been the highest in the United Kingdom. Now, instead of beating old ladies with bike chains or fighting each other with flick knives and knuckle-dusters, the kids would save their energy for playing the drums or guitar, and for having fun. Liverpool, a port of great traditions, run down somewhat by the war and by post-war negligence, had entered a new glorious chapter of its history by becoming the city of The Beatles, and the message radiated all around the world.

I had a really good time there. It often reminded me of my home town, Hamburg, also a port crippled by the war, to be seen most of the time with a cold grey sky looming up above it. Maybe, it was not a coincidence that The Beatles had their first major success in Hamburg.

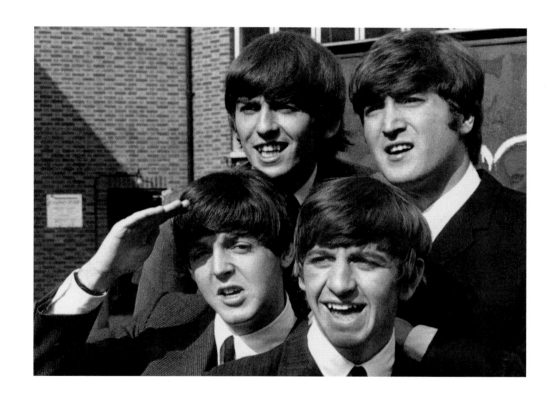

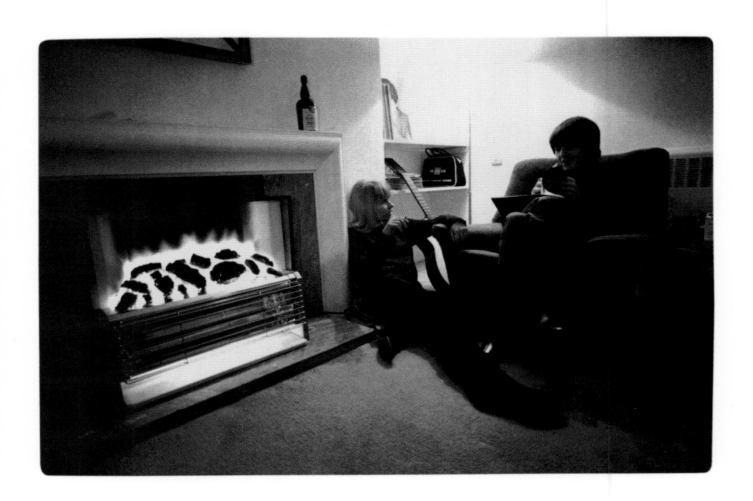

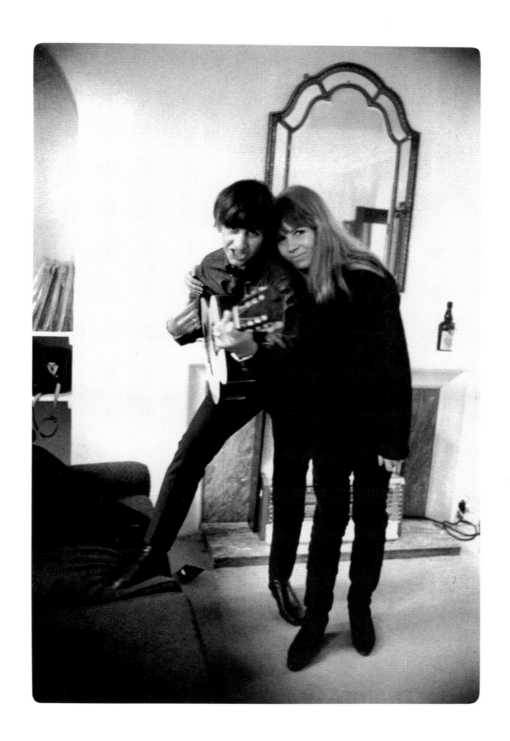

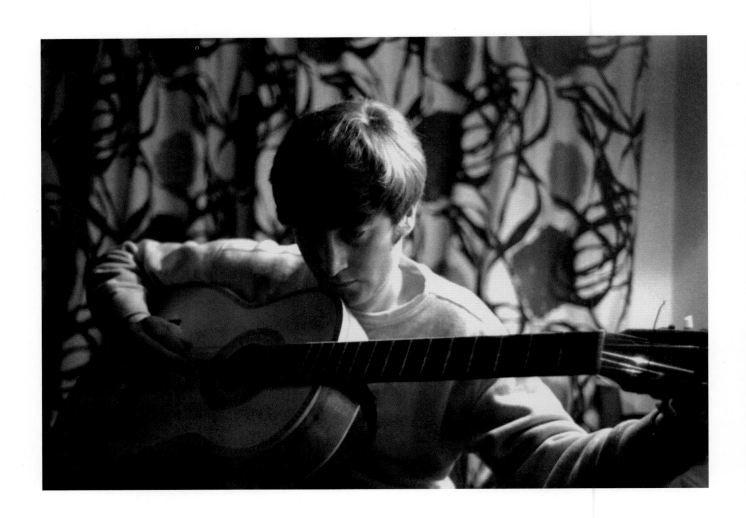

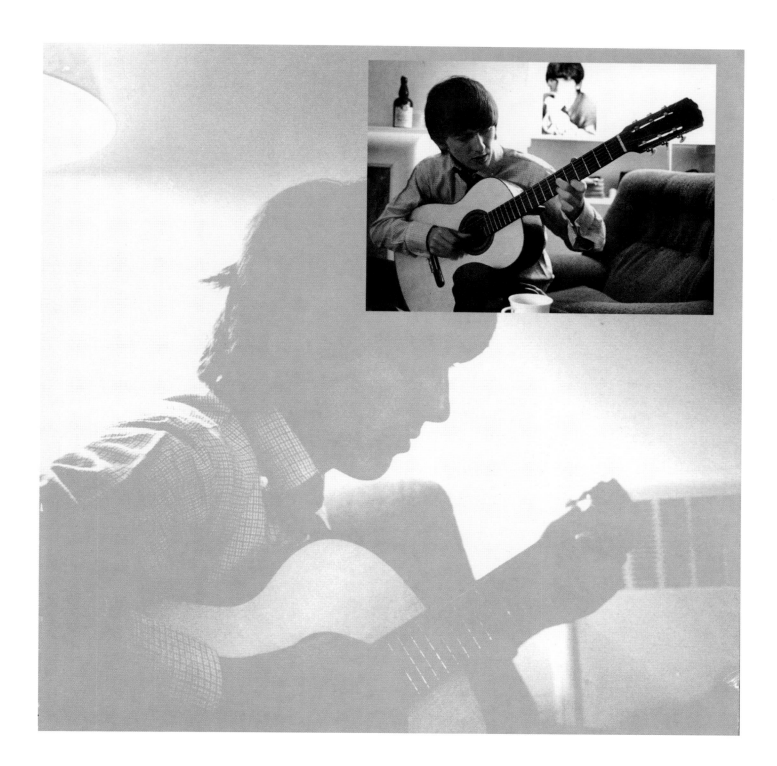

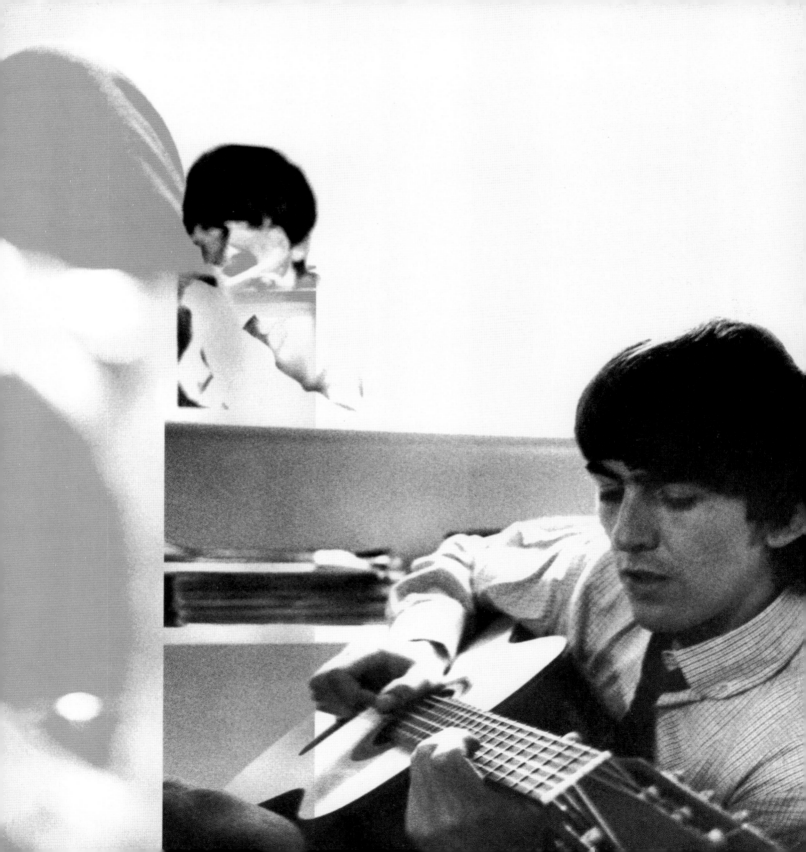

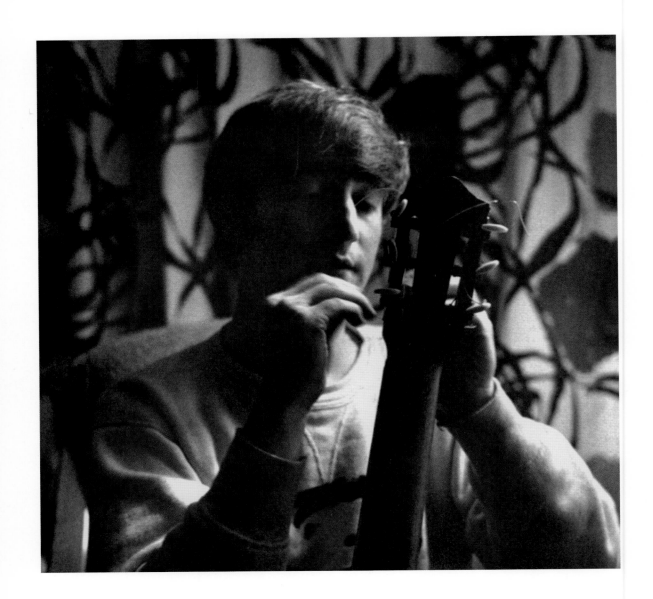

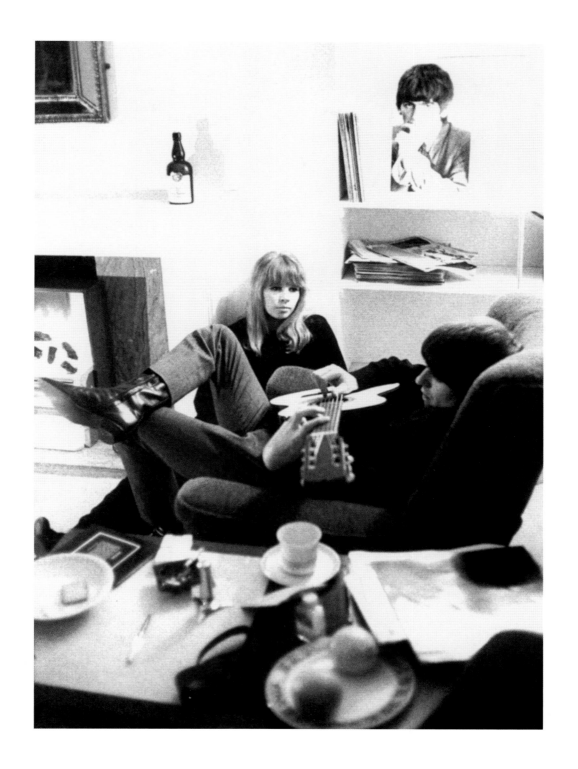

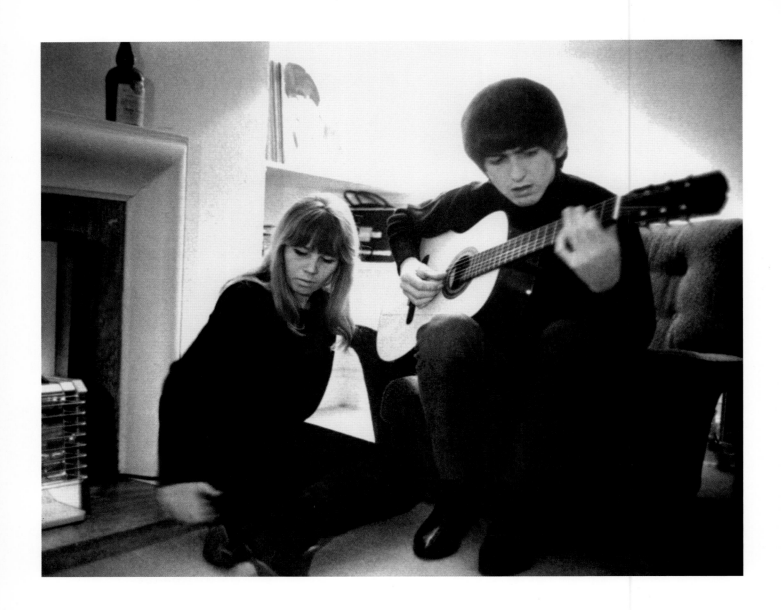

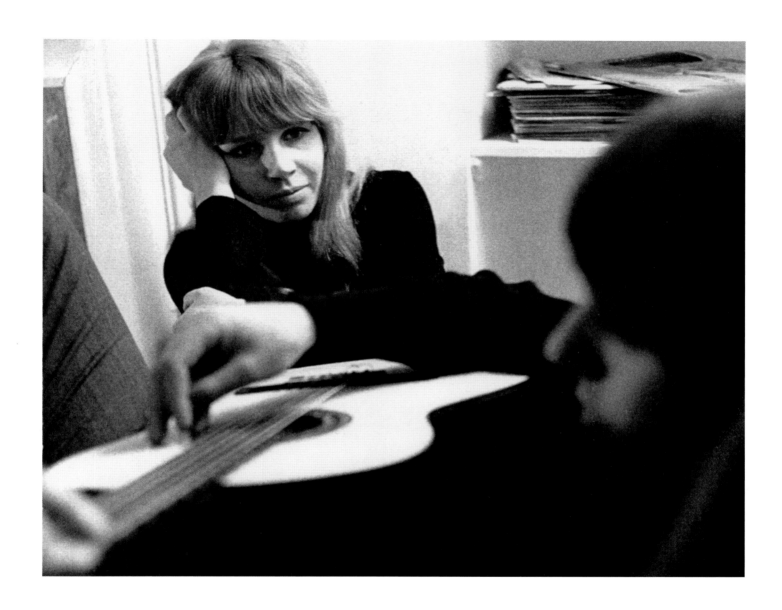

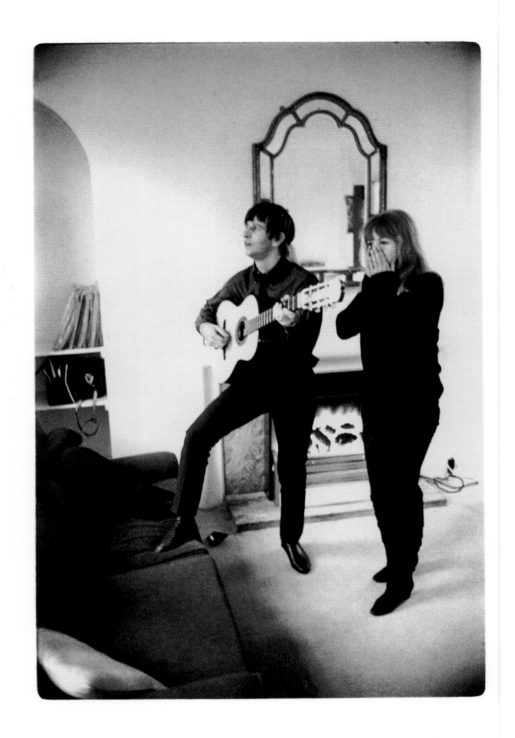

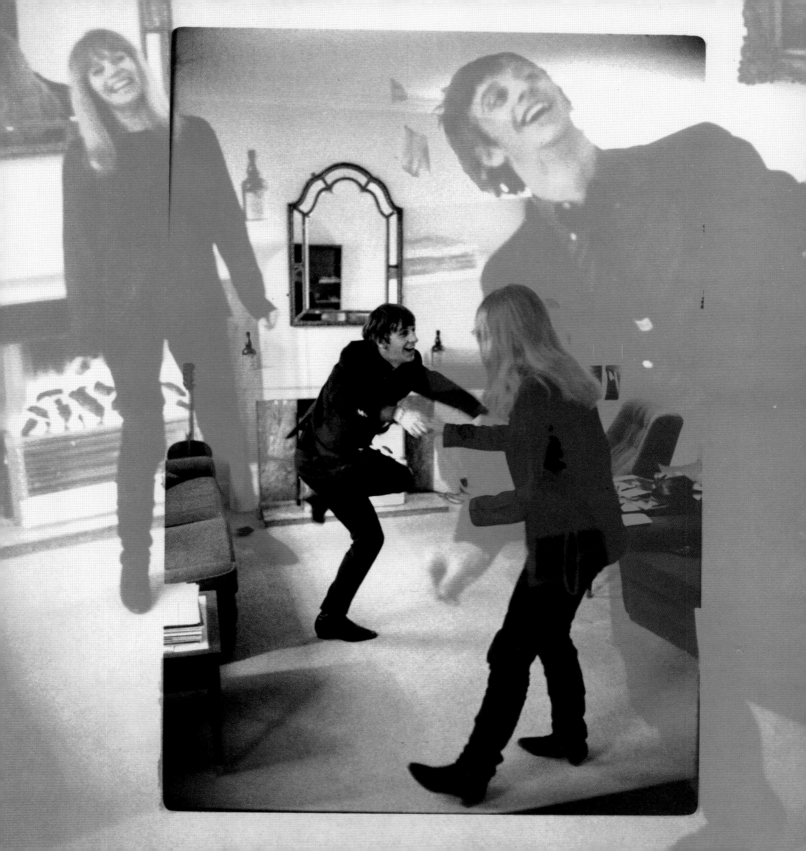

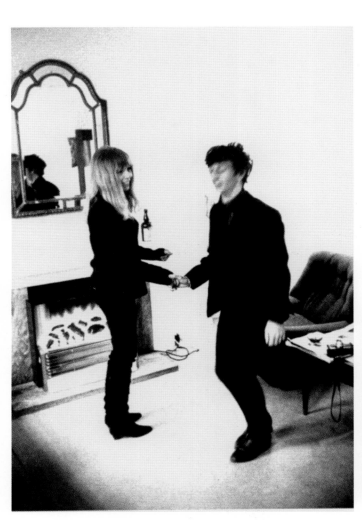

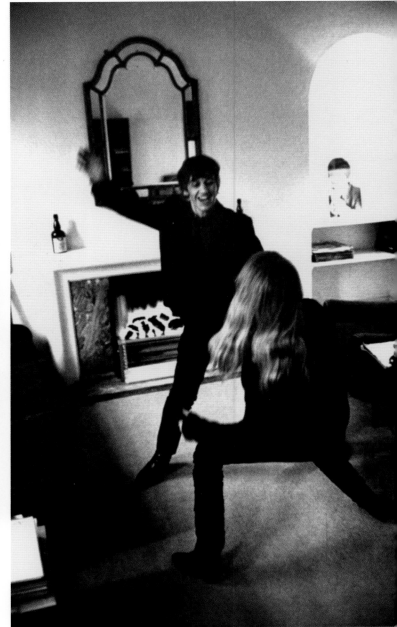

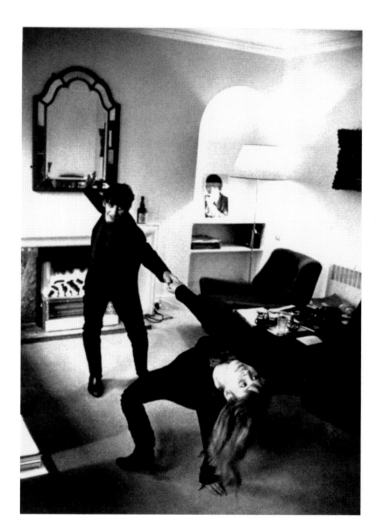
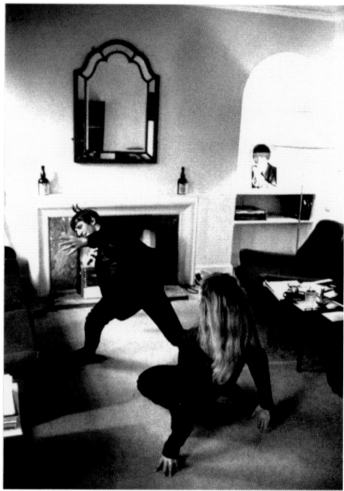

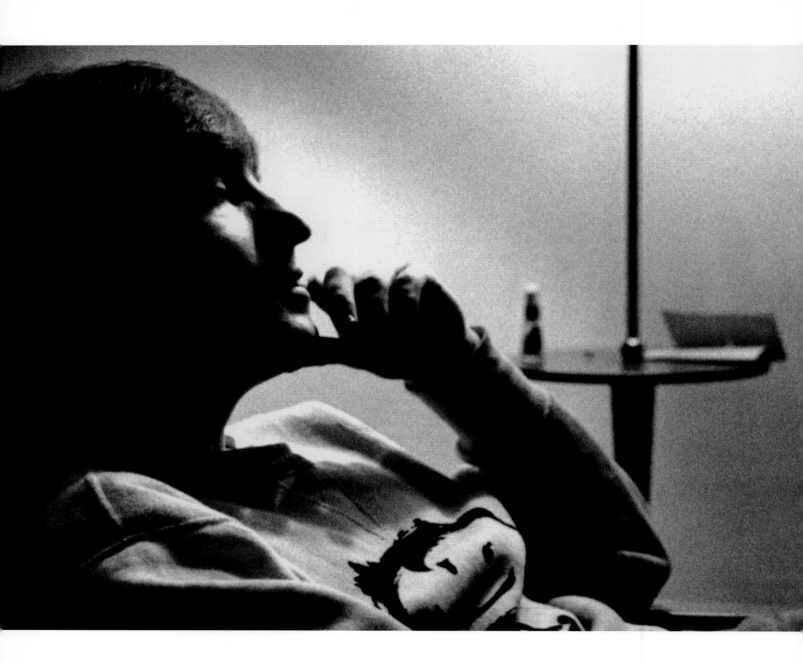

28

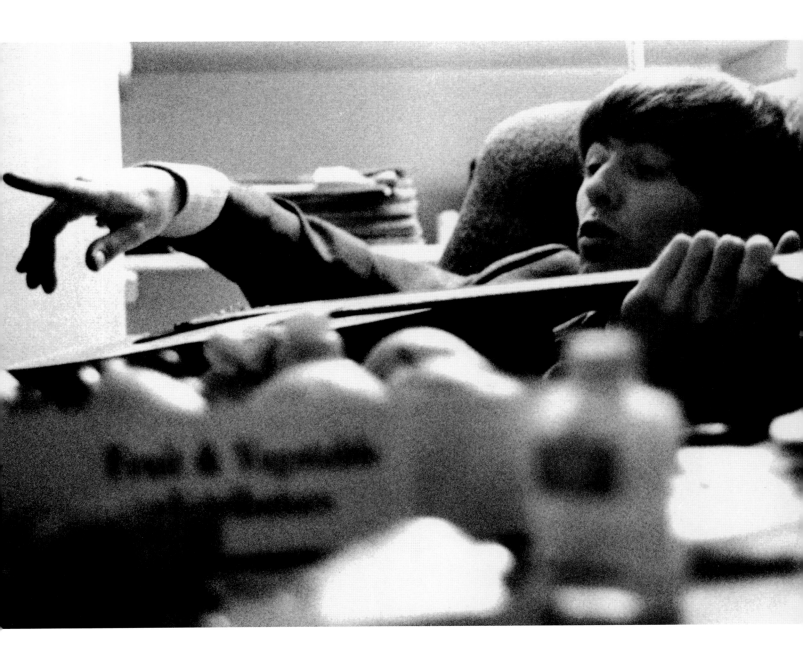

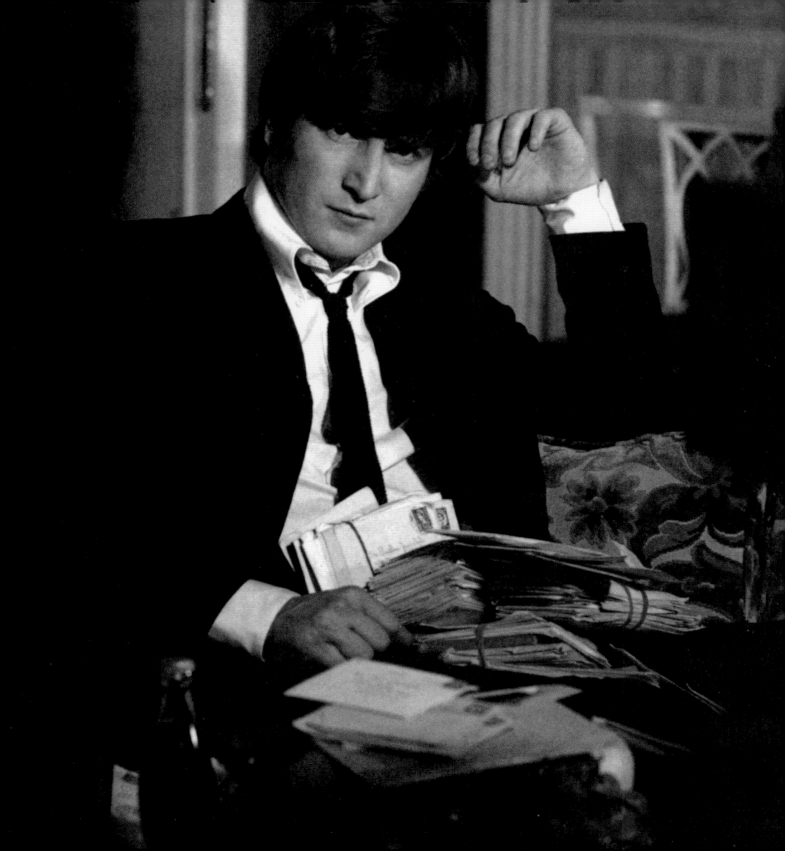

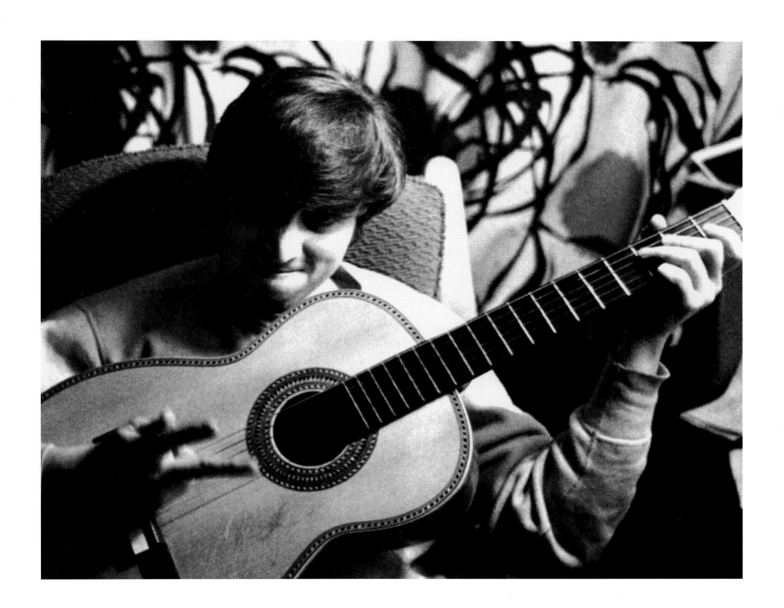

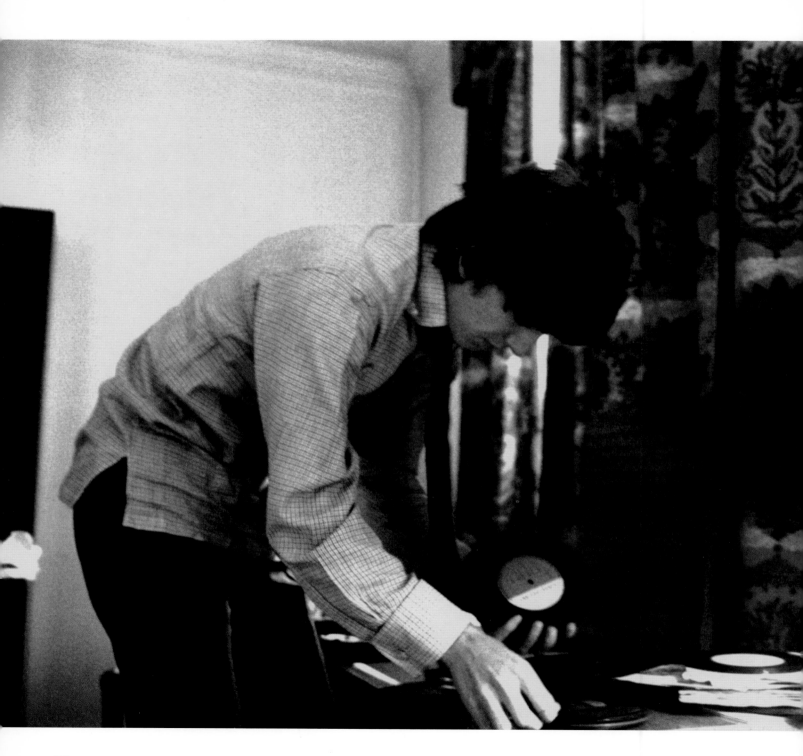

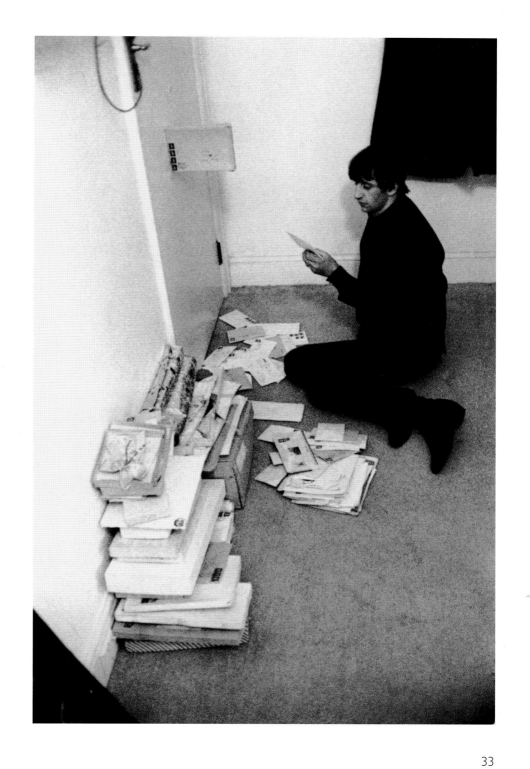

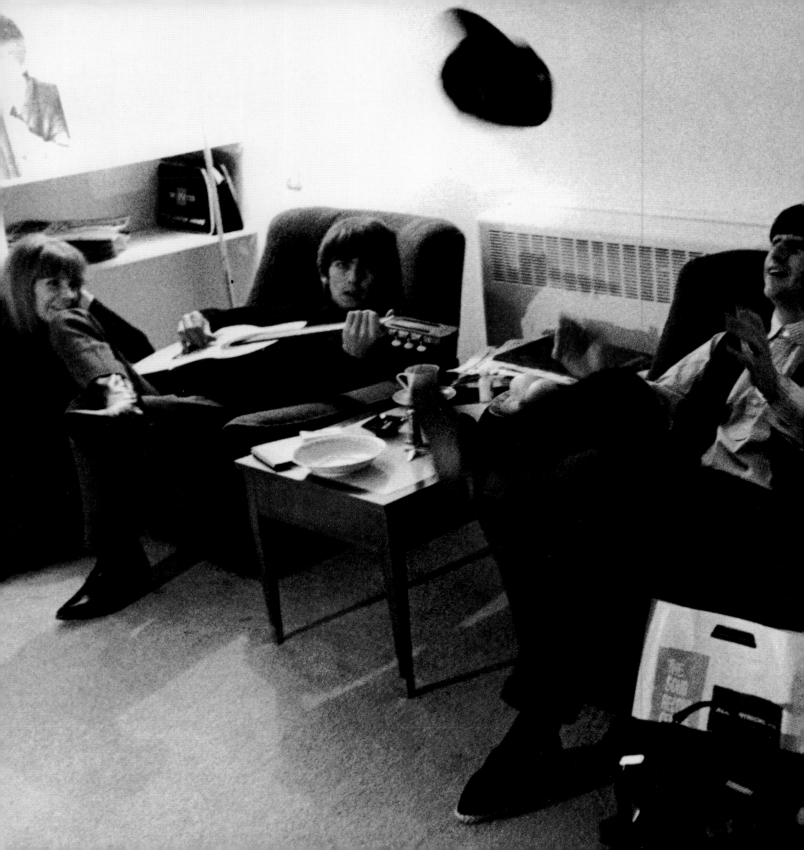

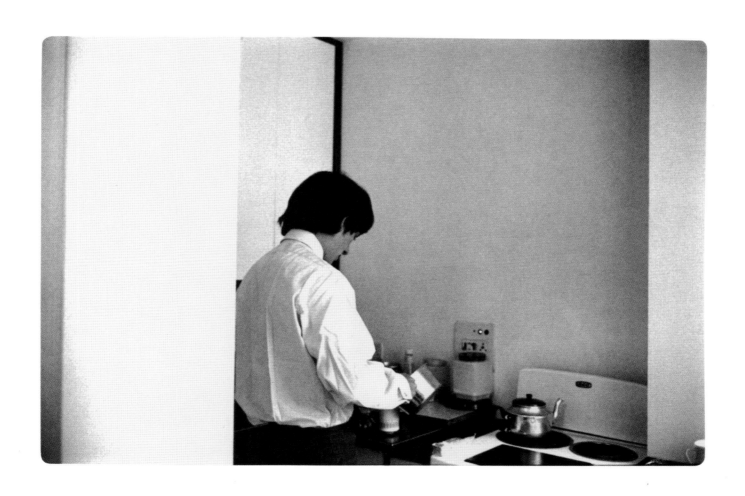

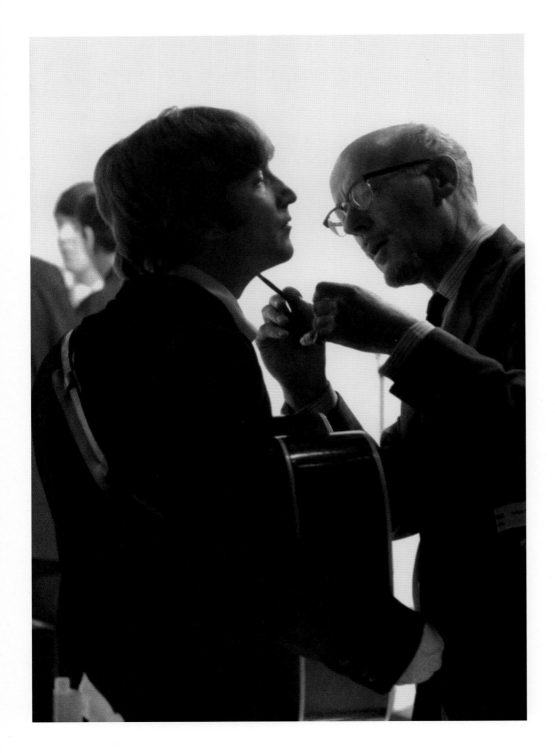

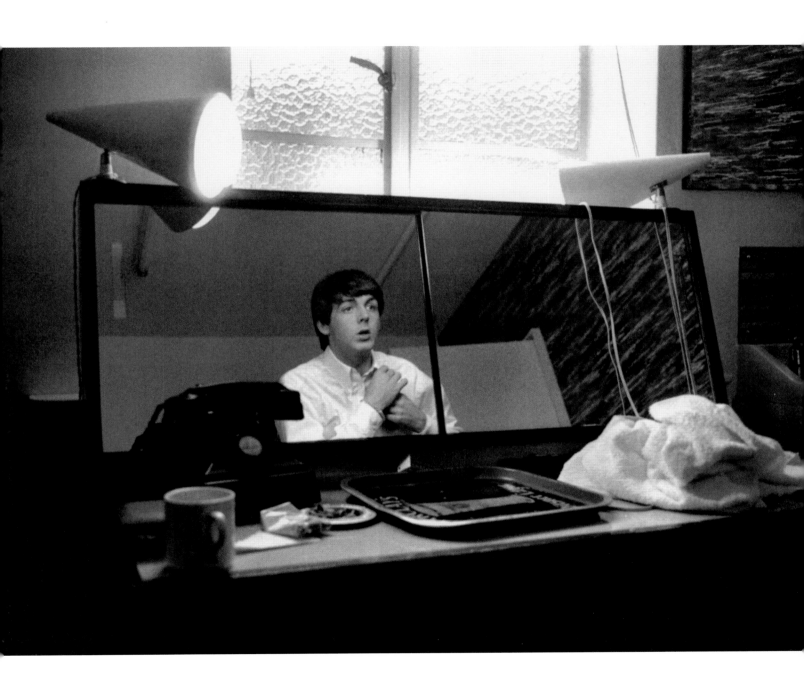

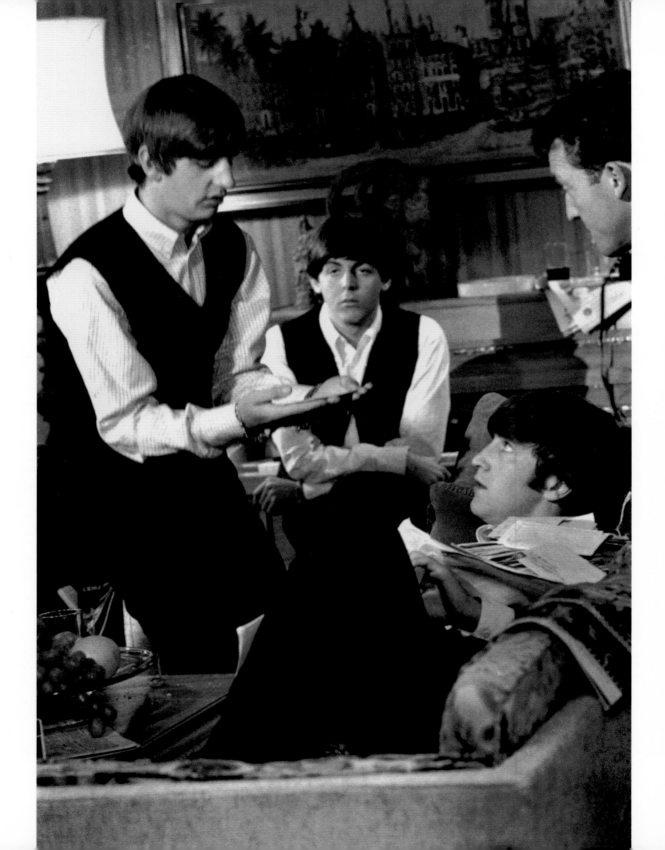

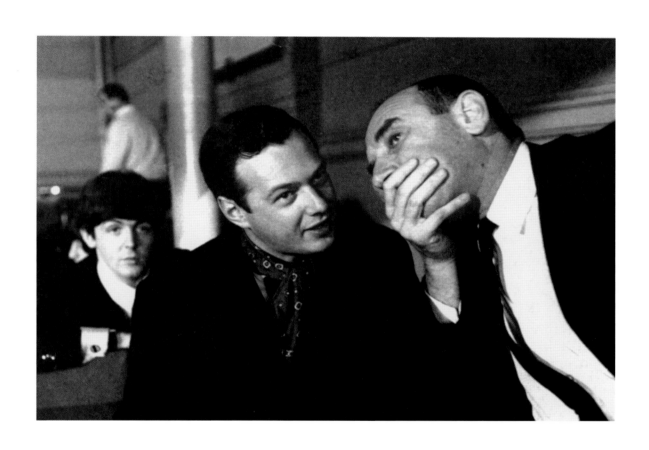

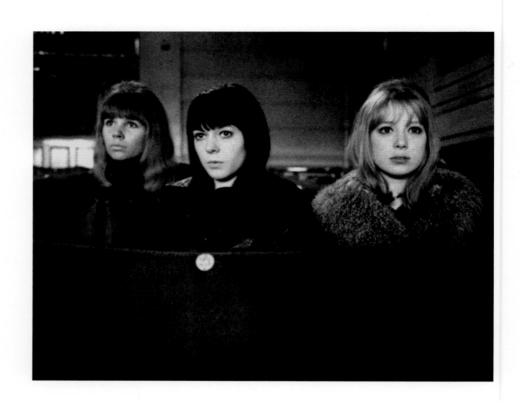

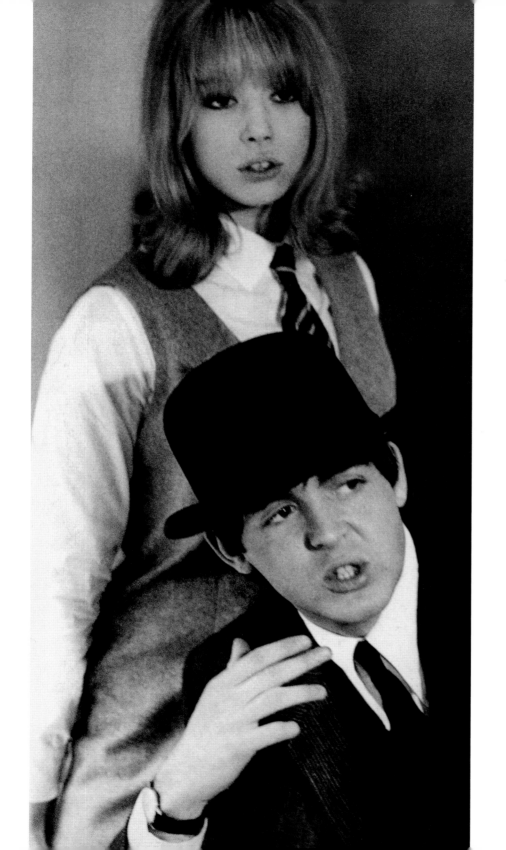

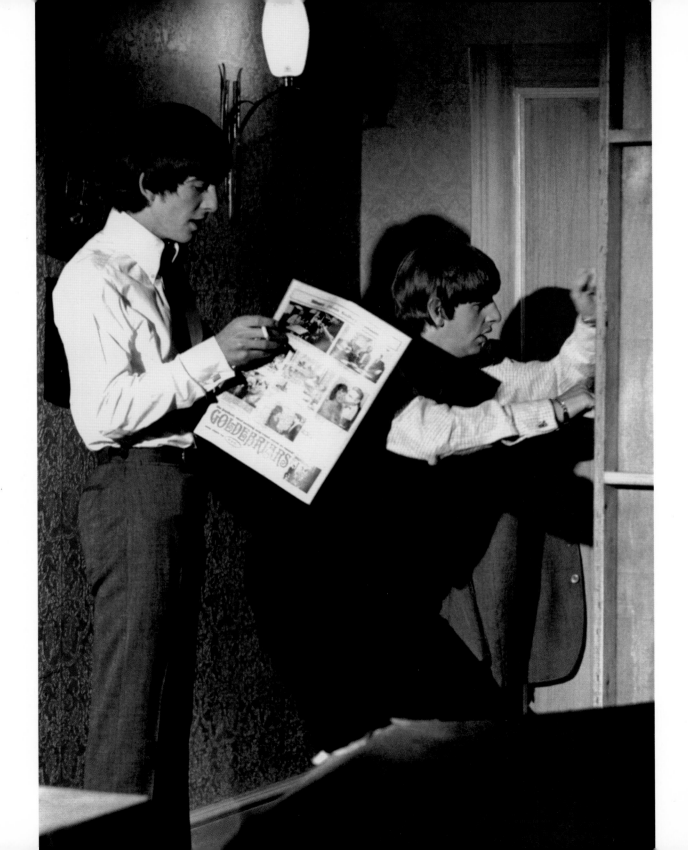

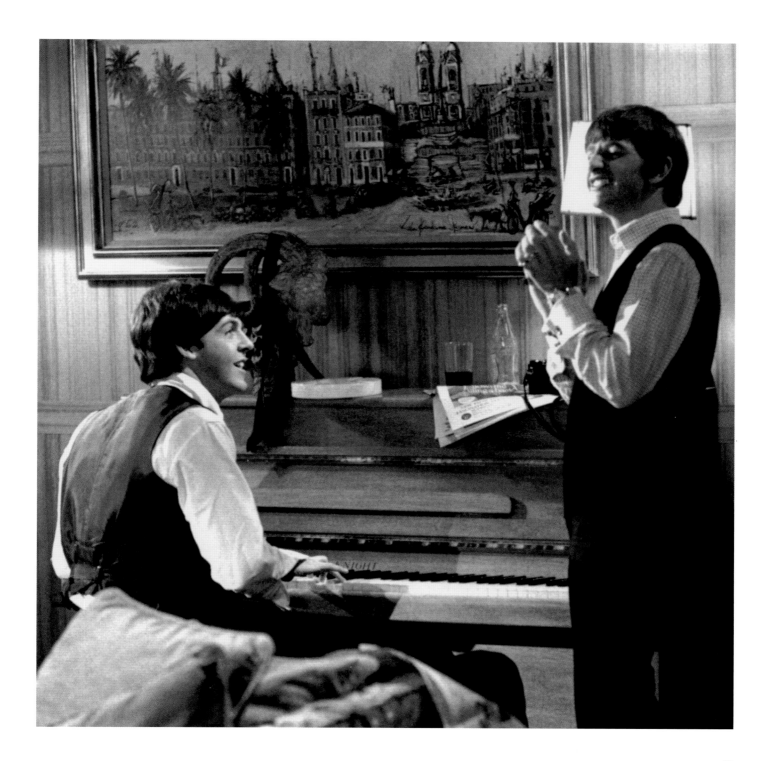

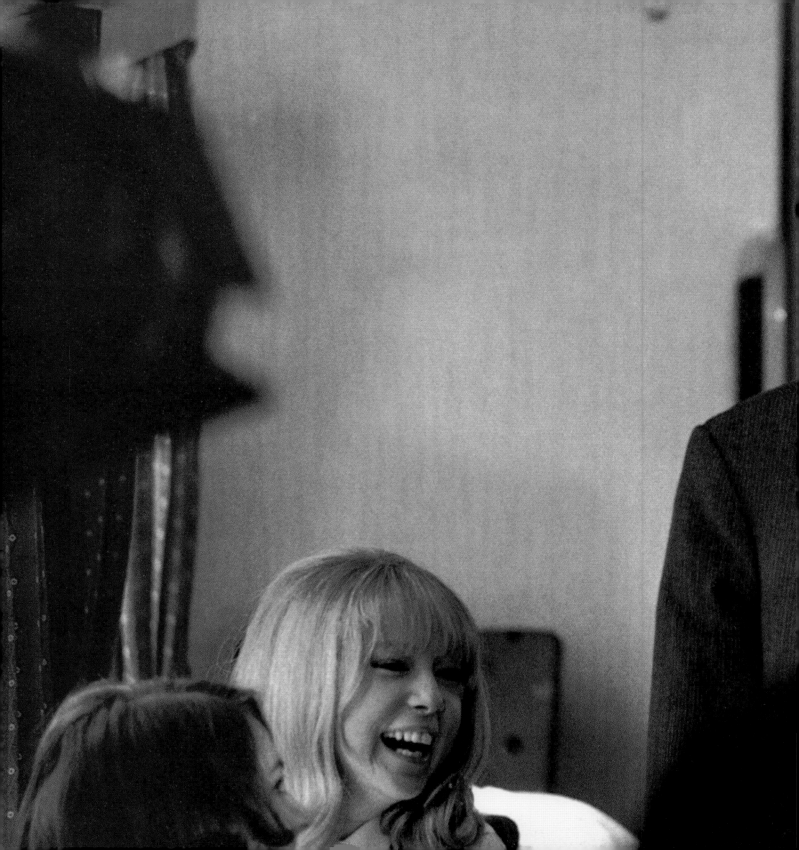

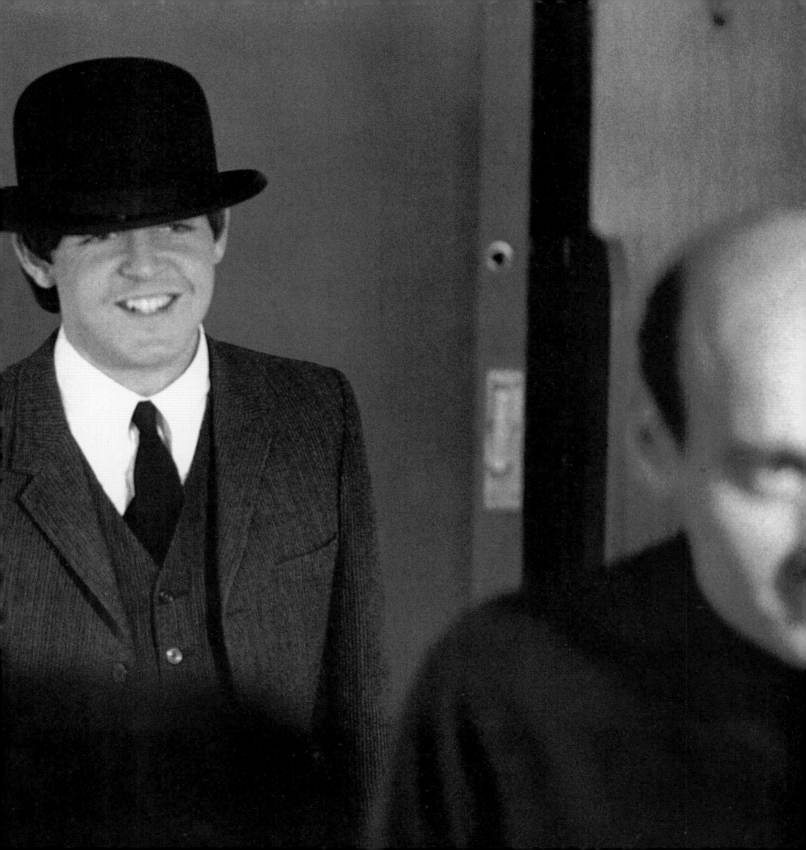

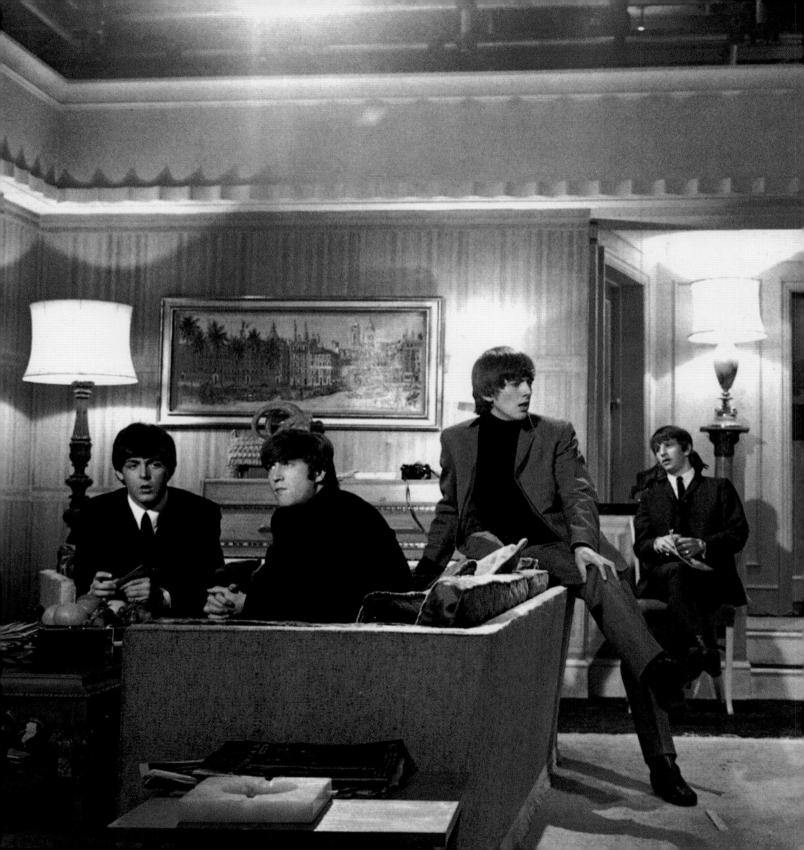

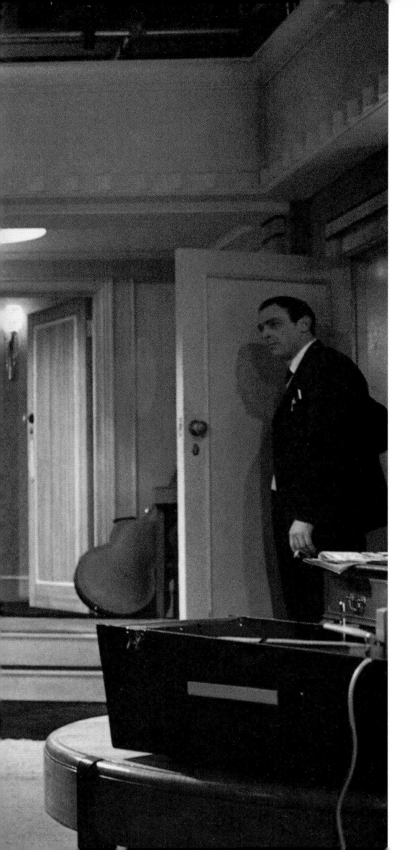

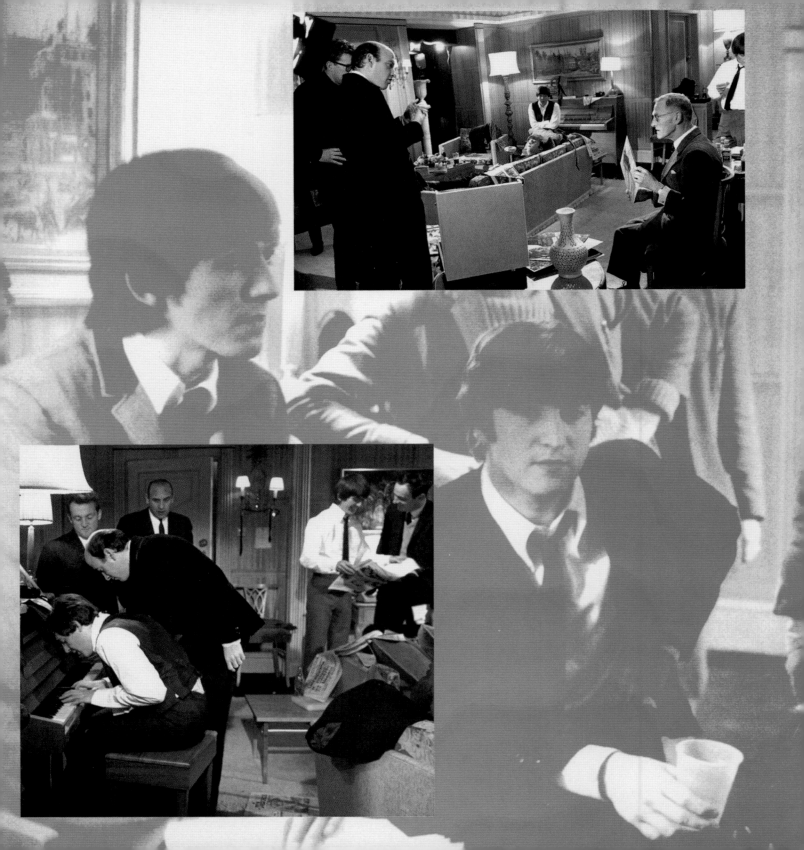

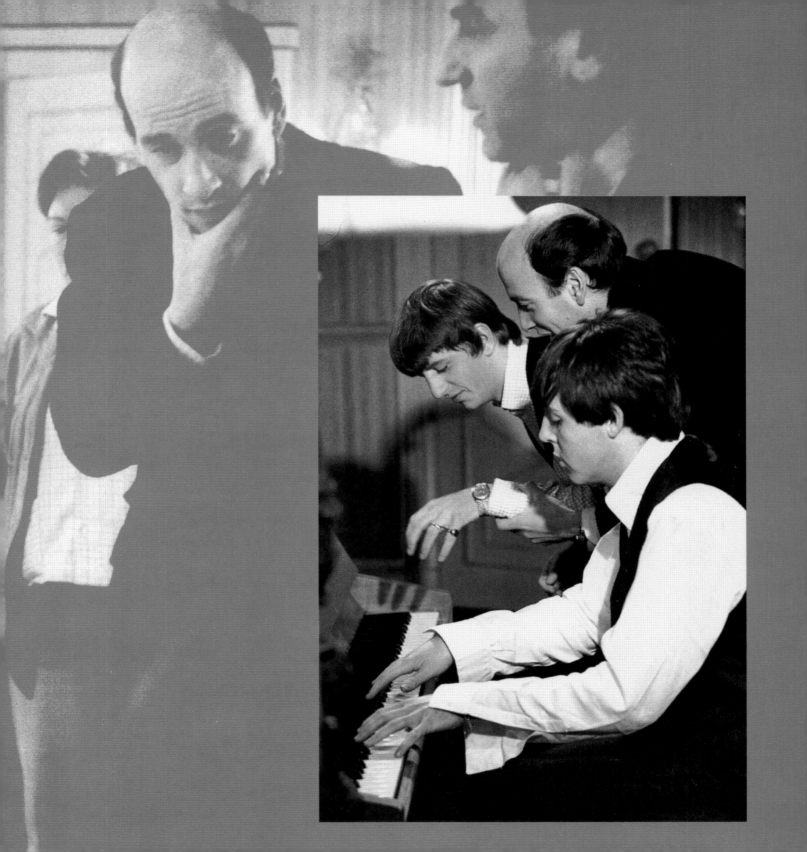

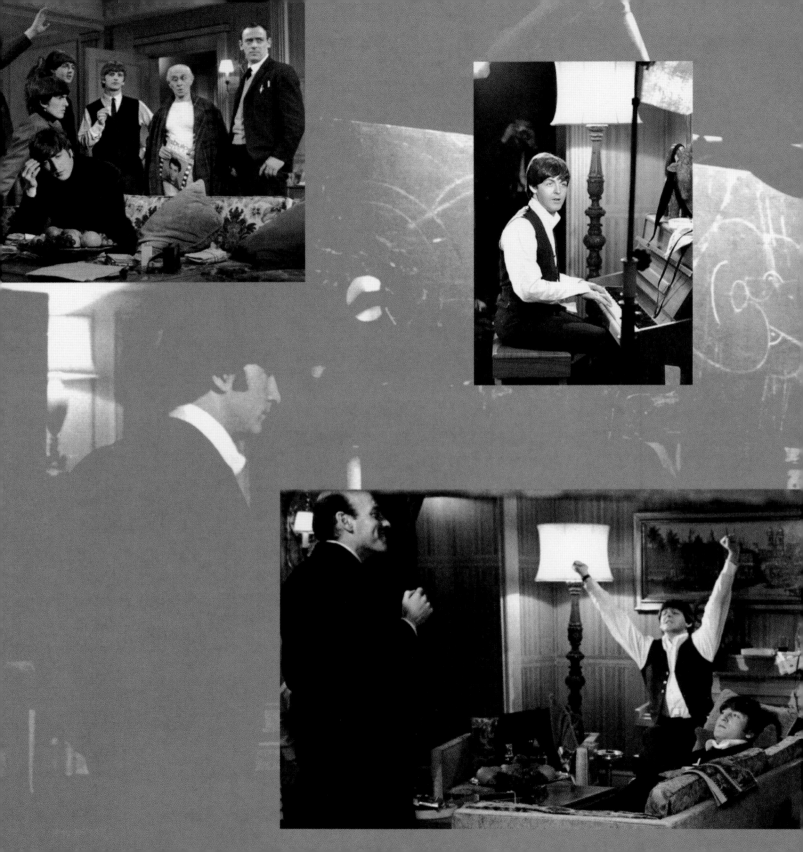

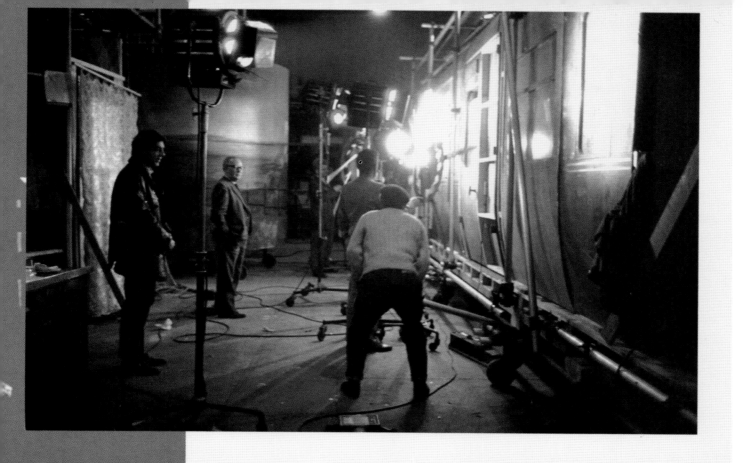

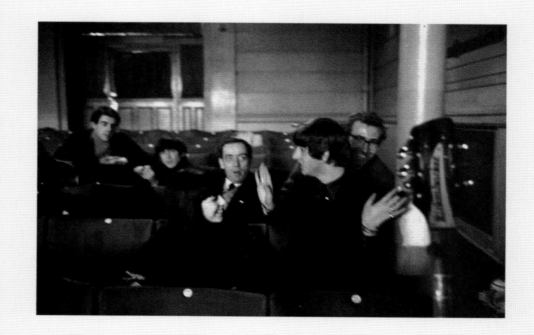

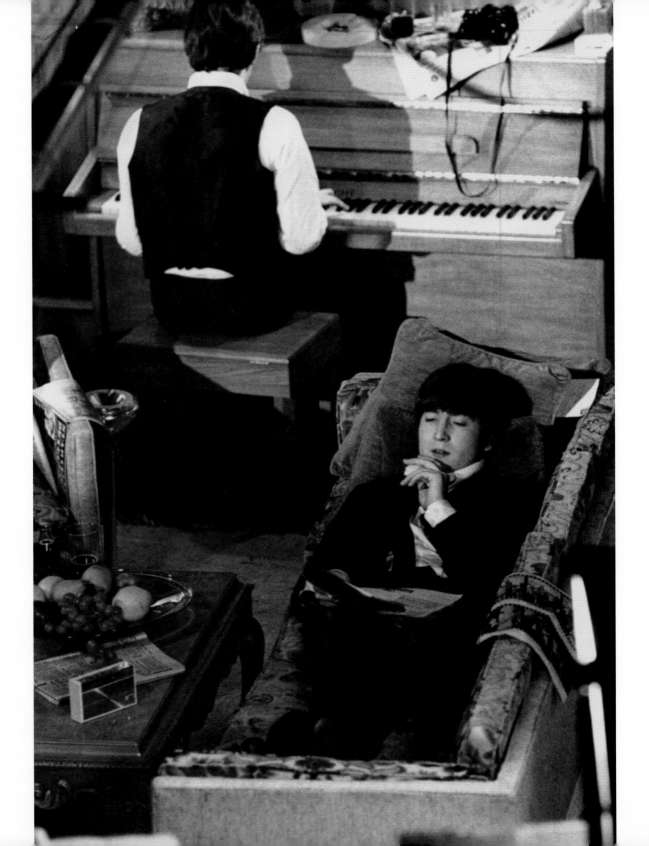

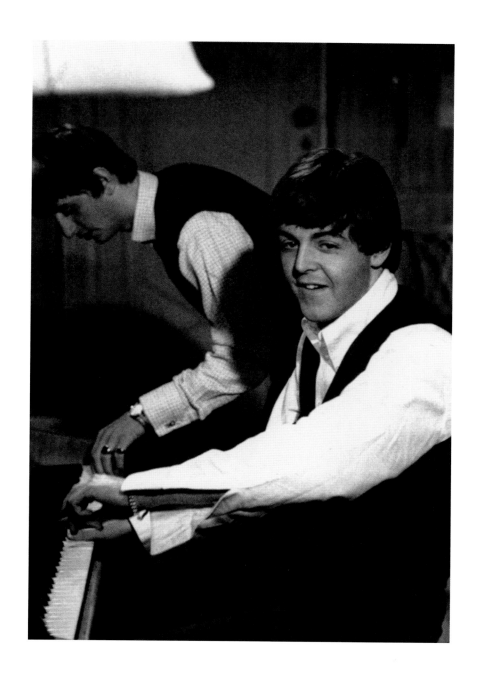

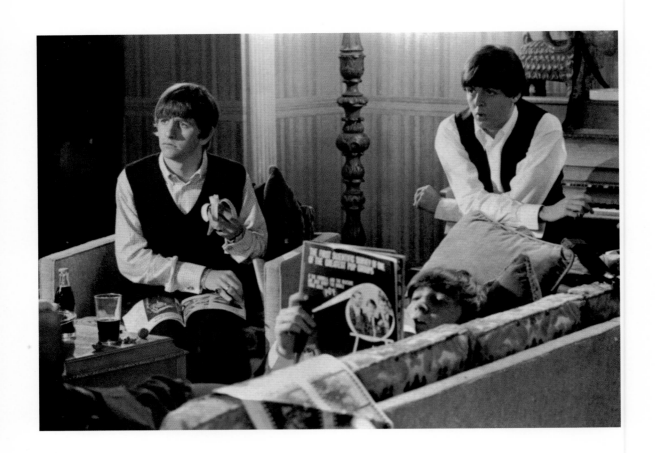

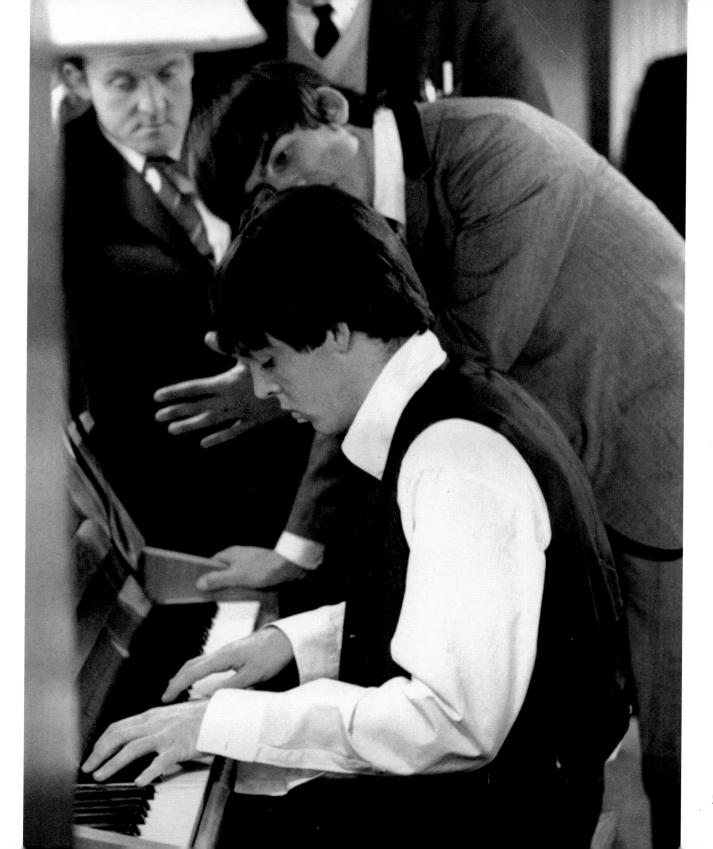

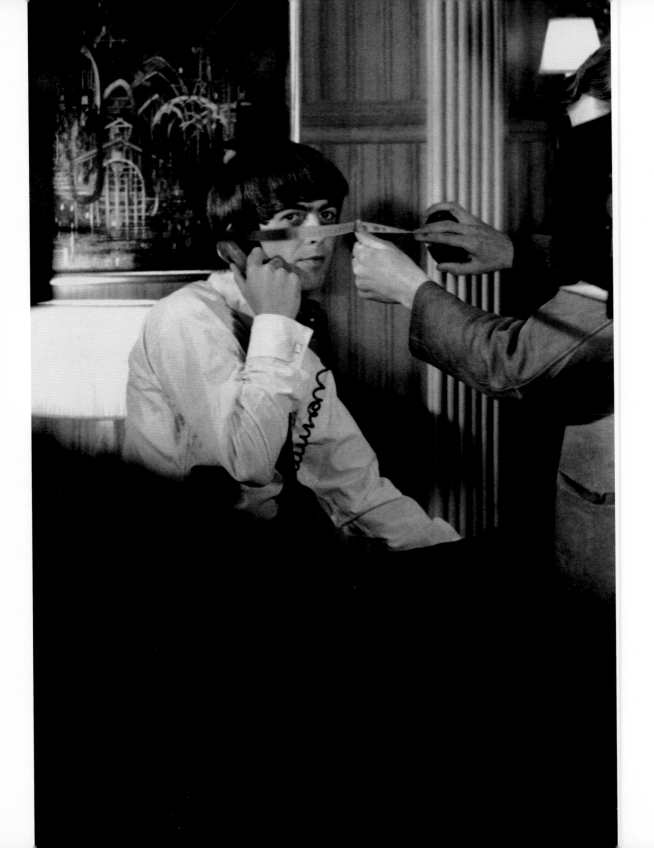

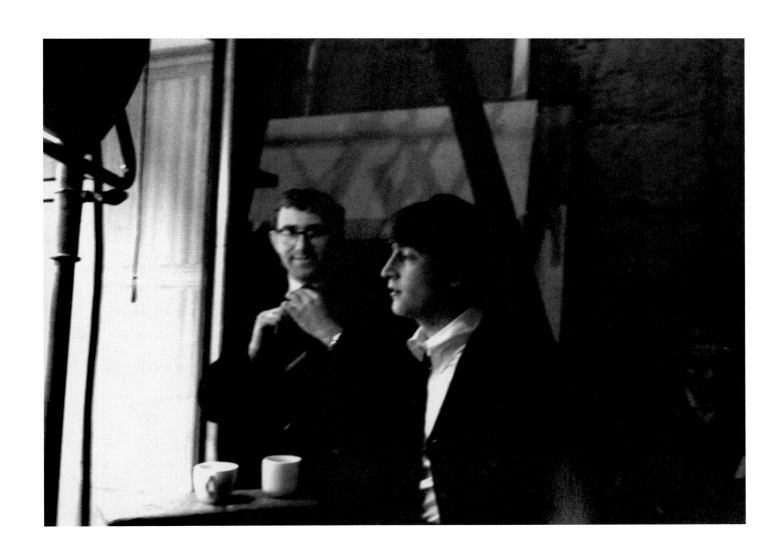

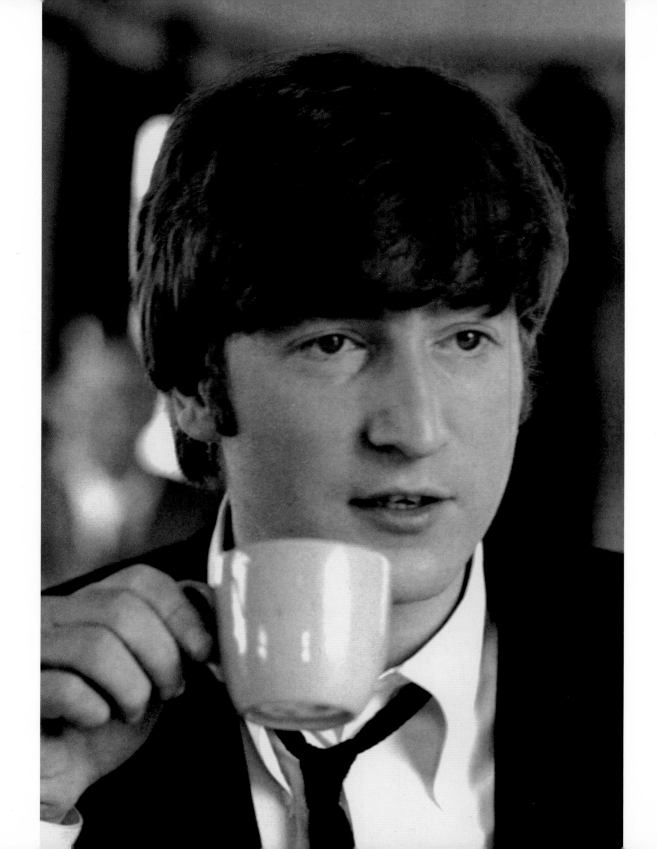

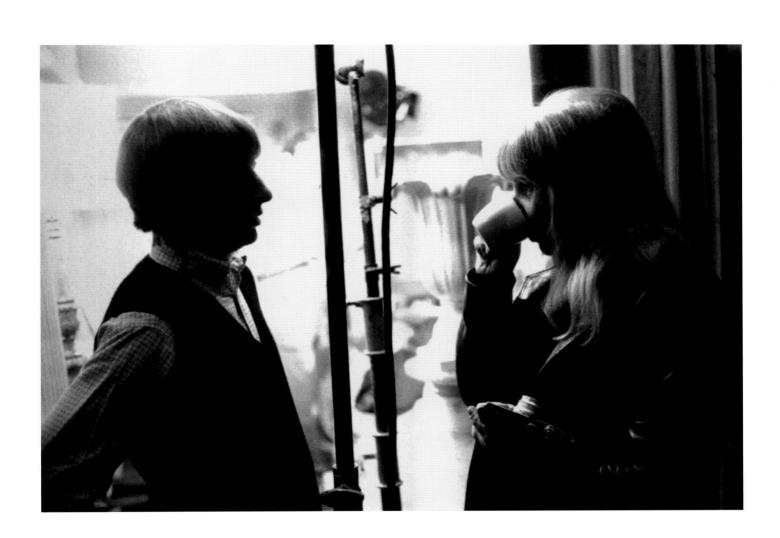

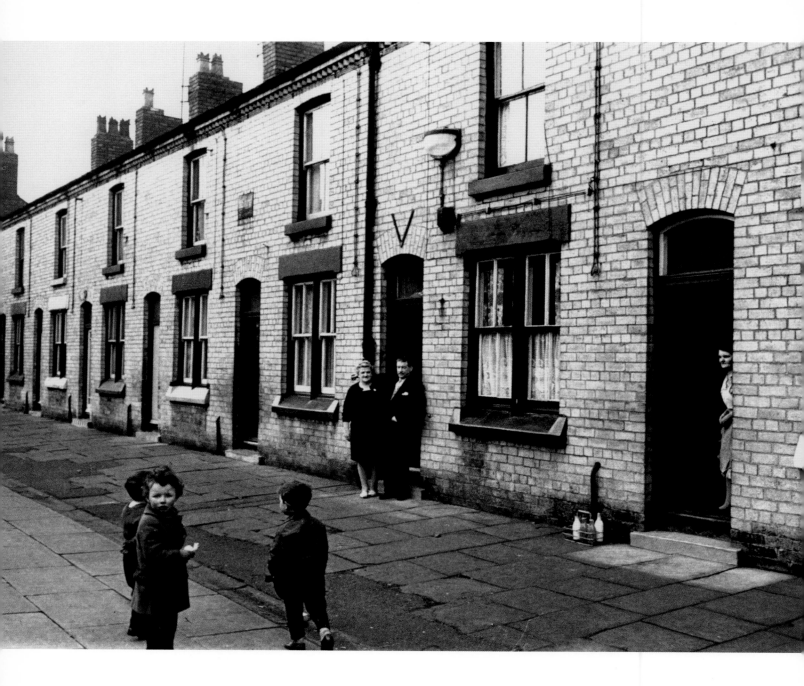

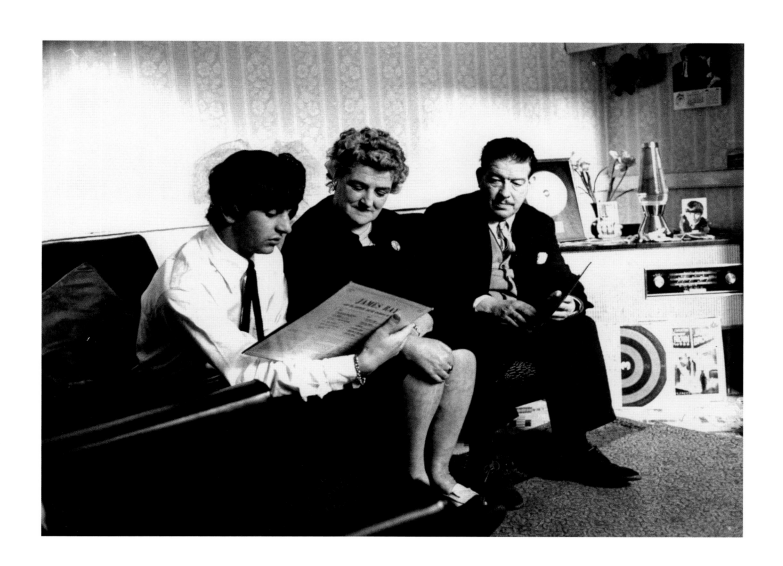

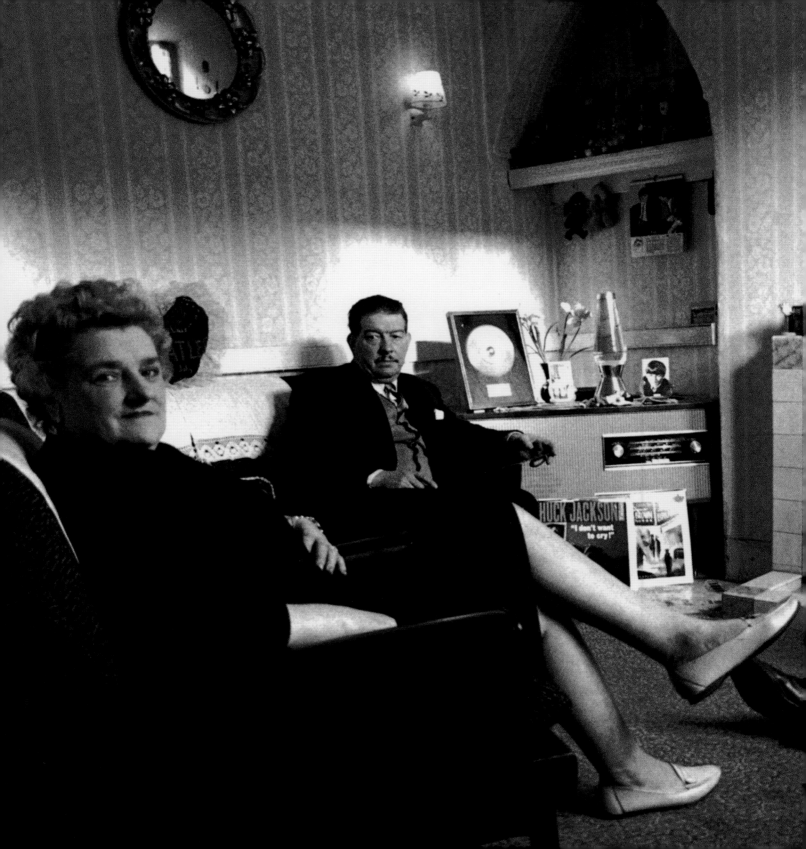

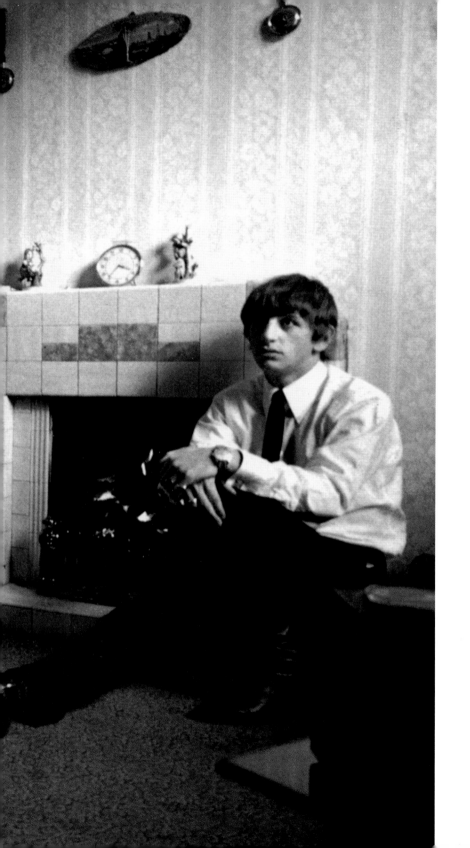

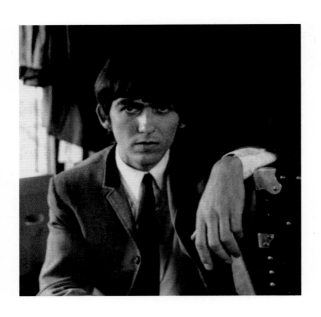

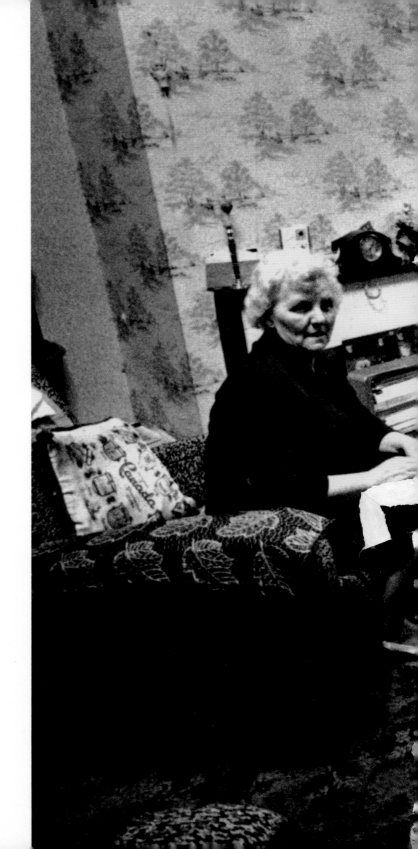

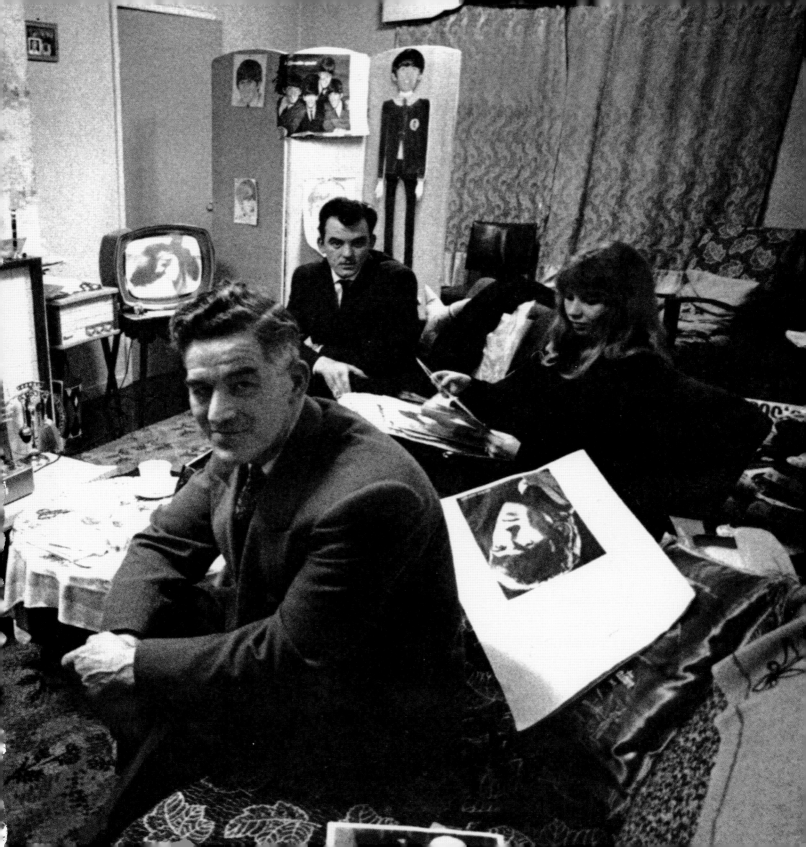

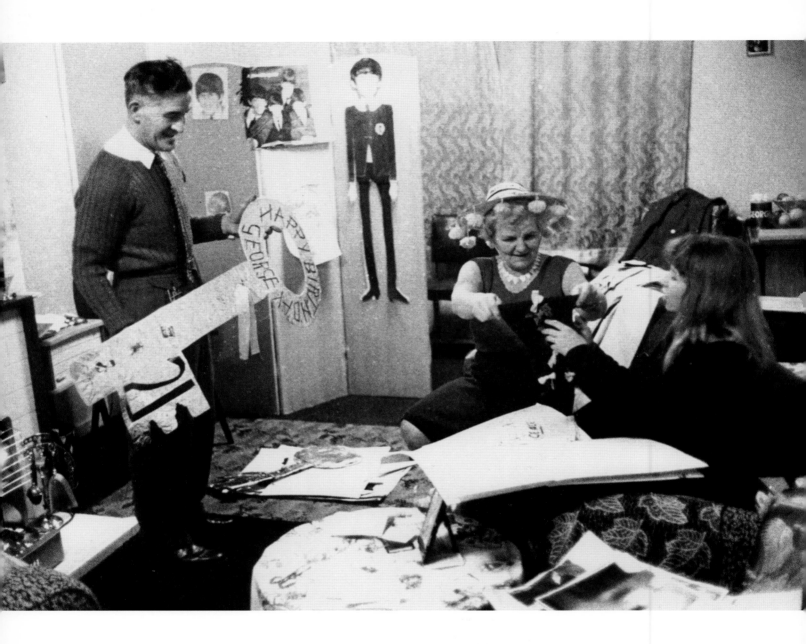

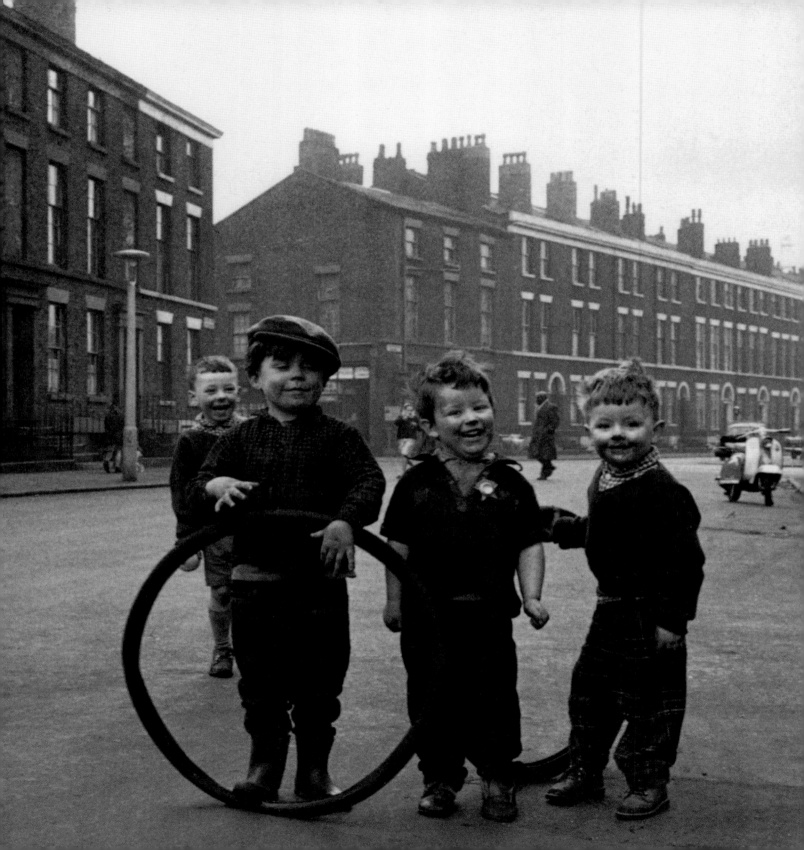

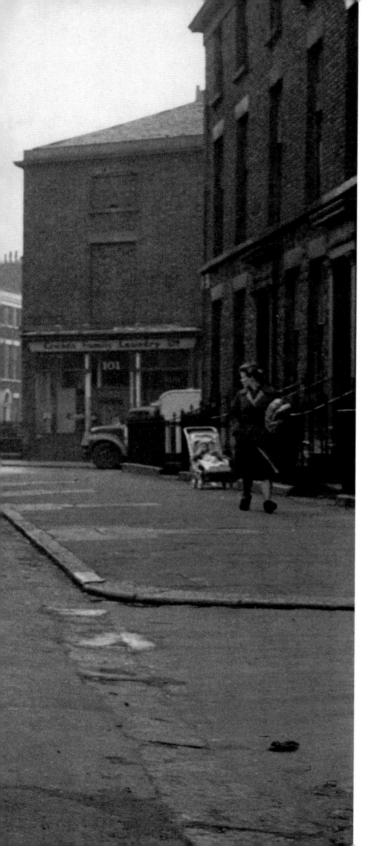

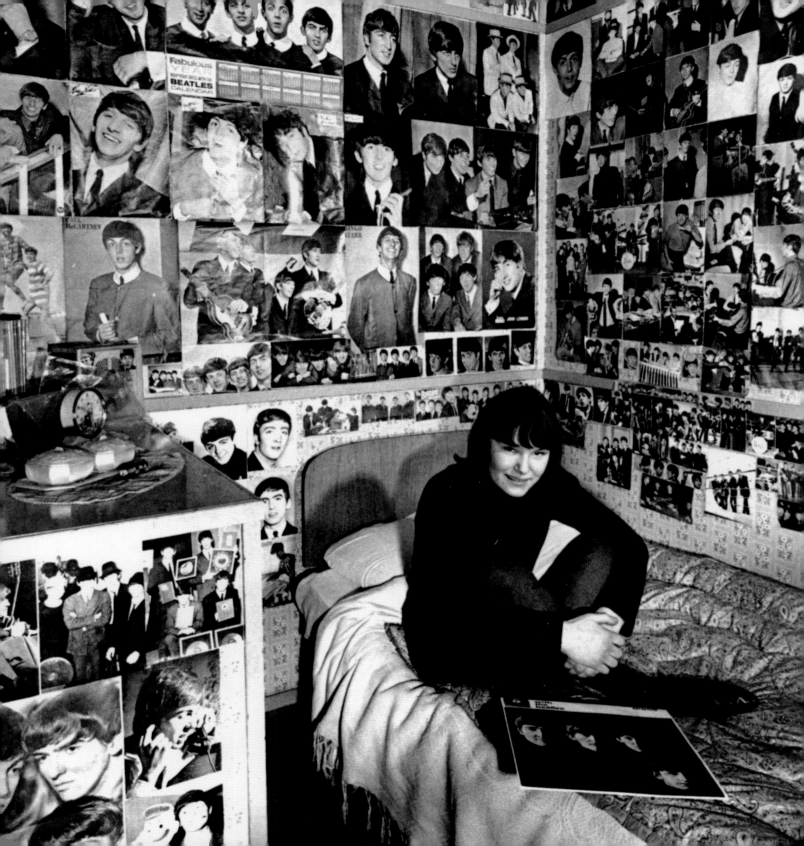

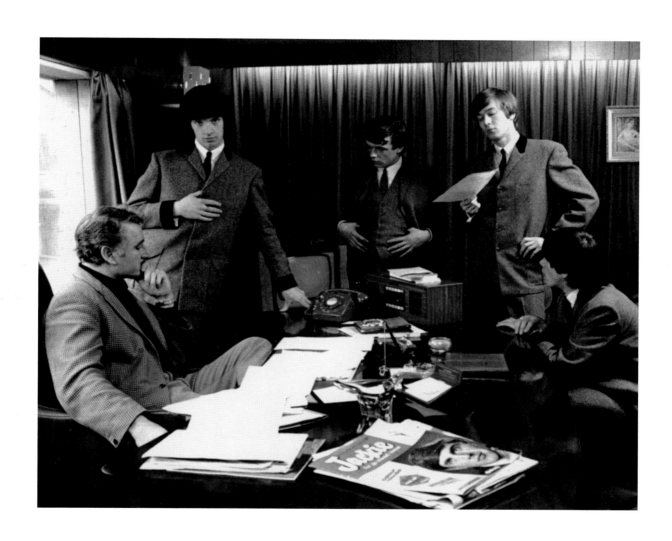

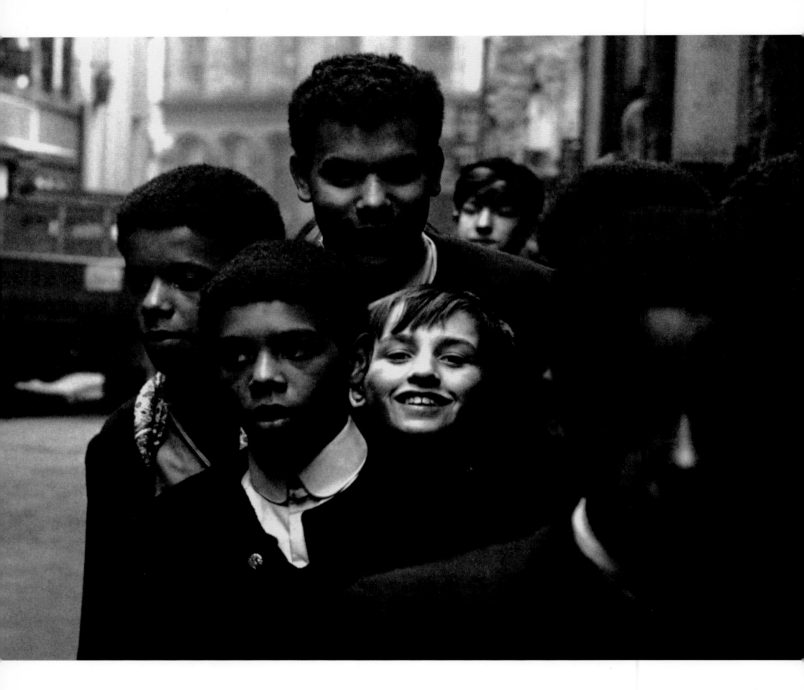

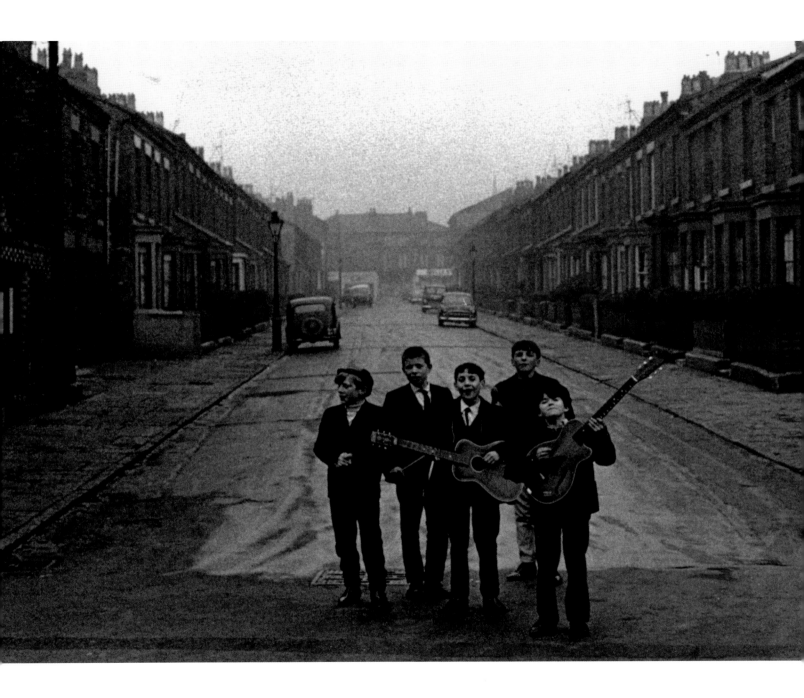

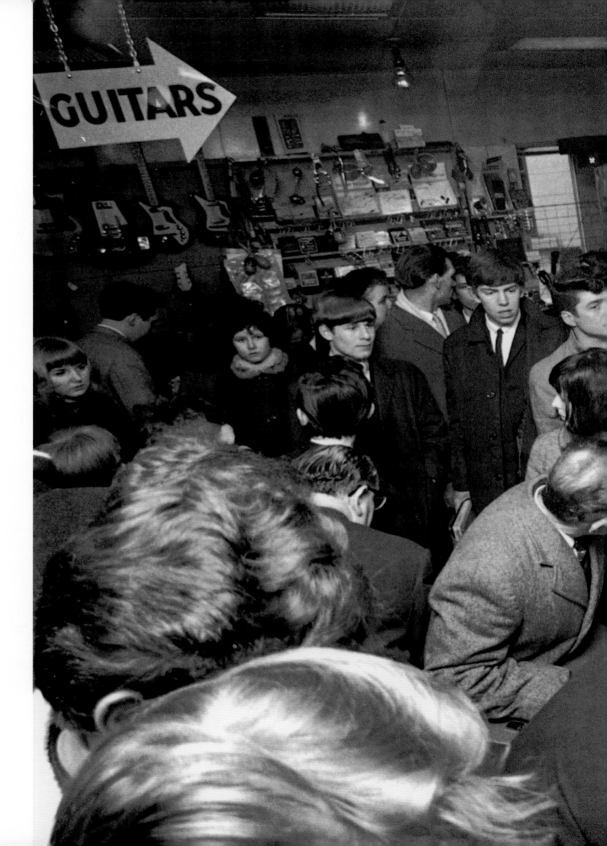

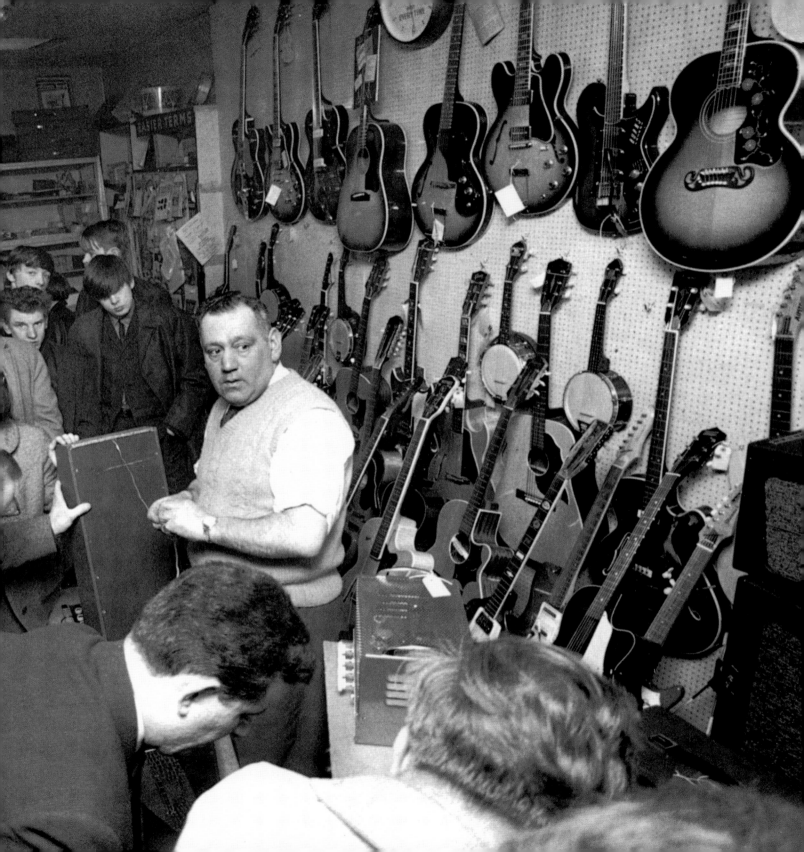

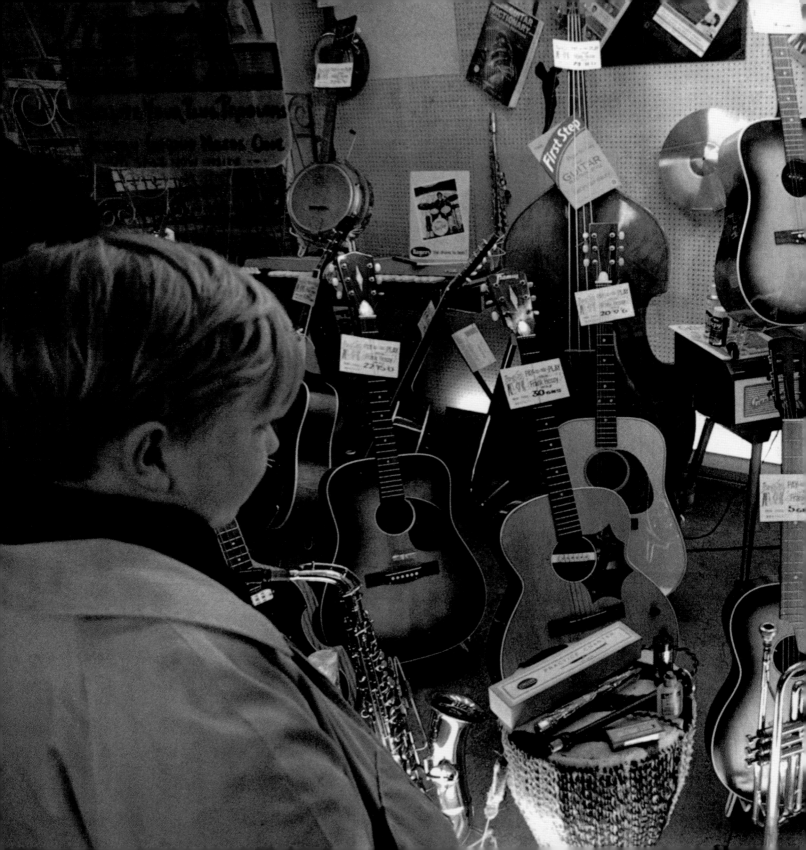

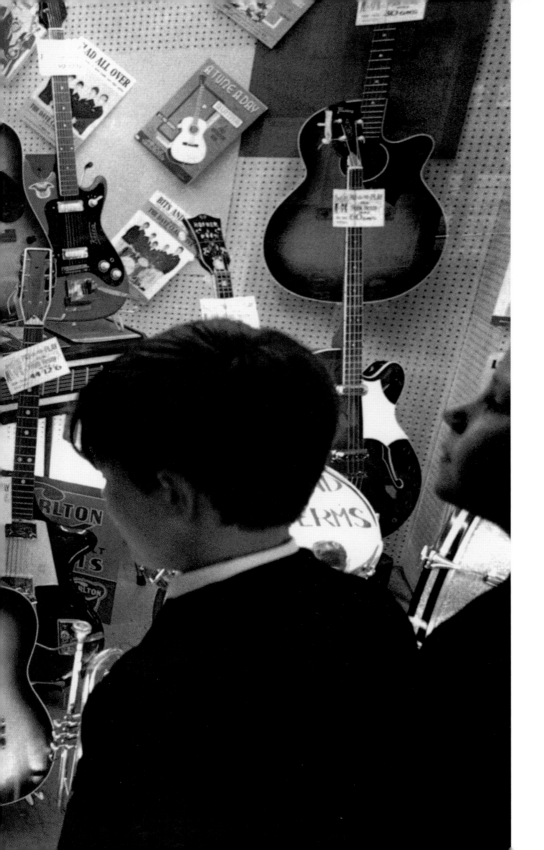

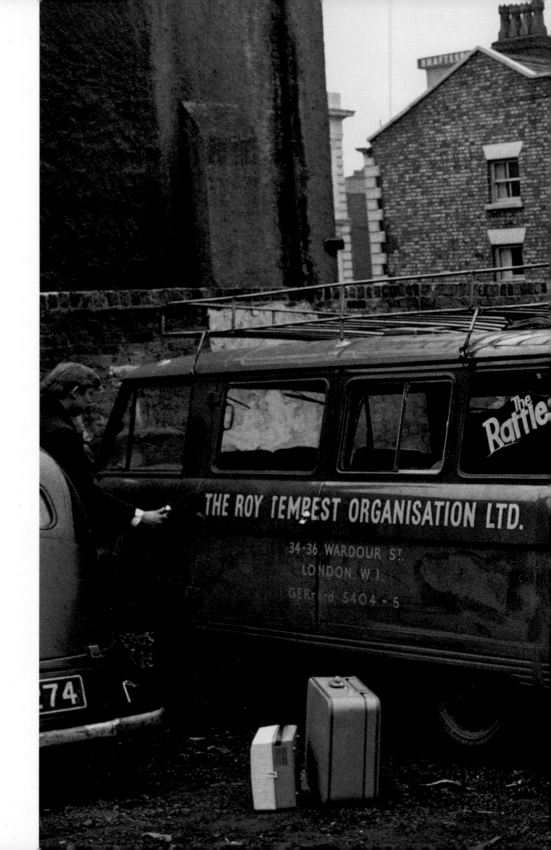

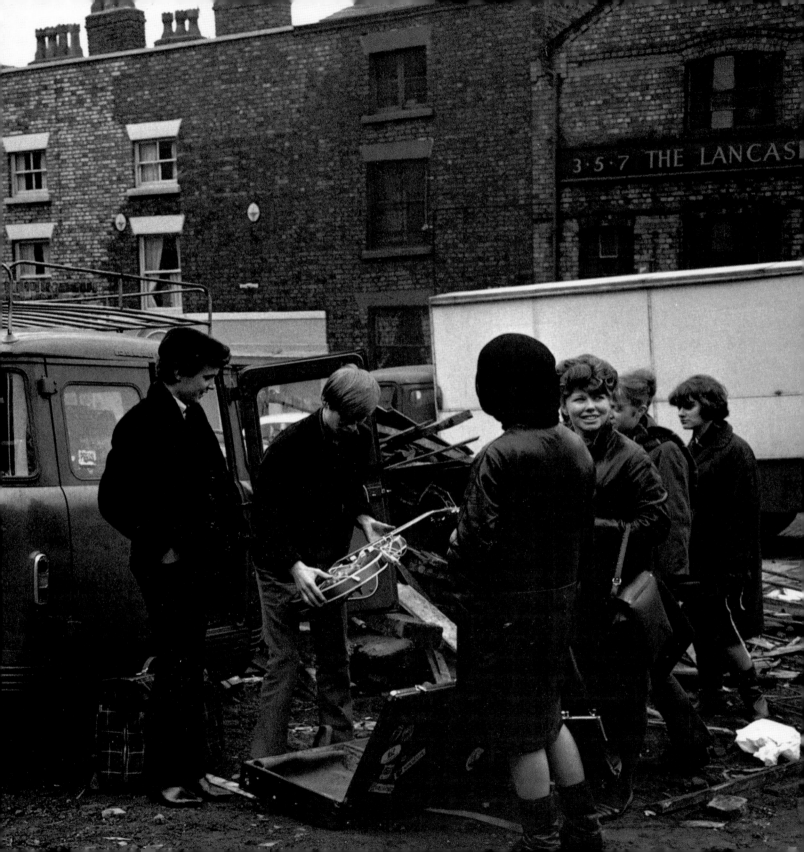

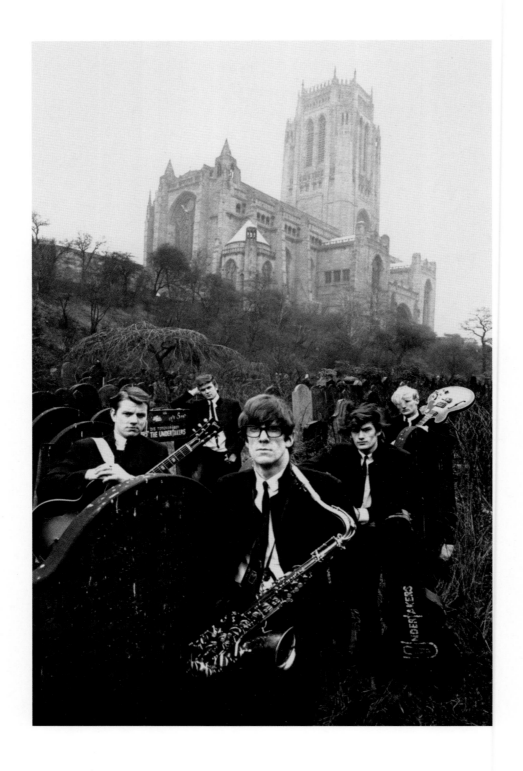

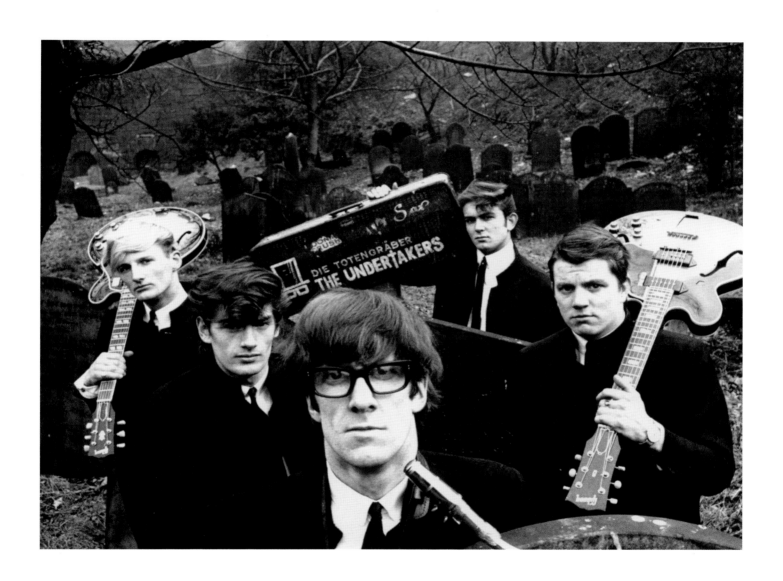

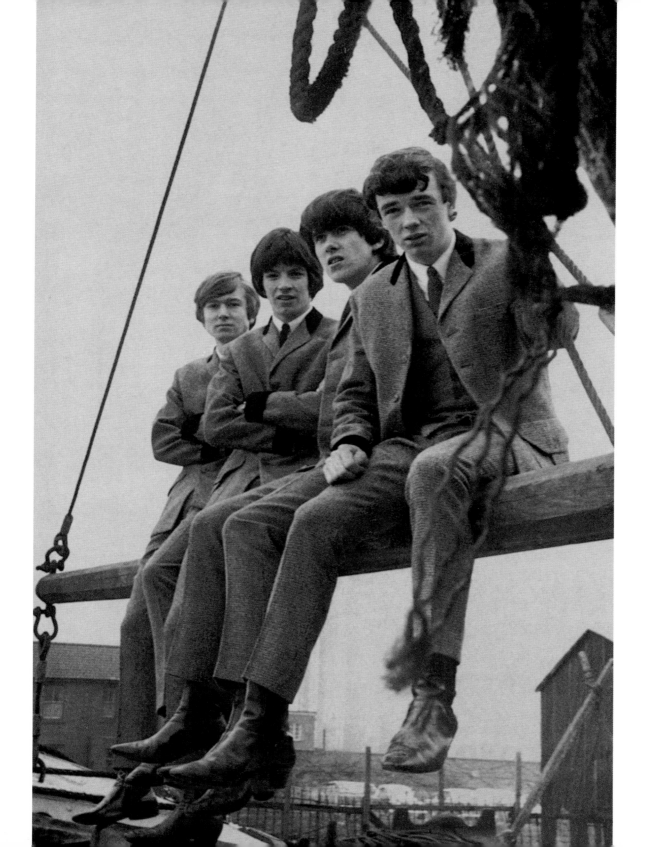

83

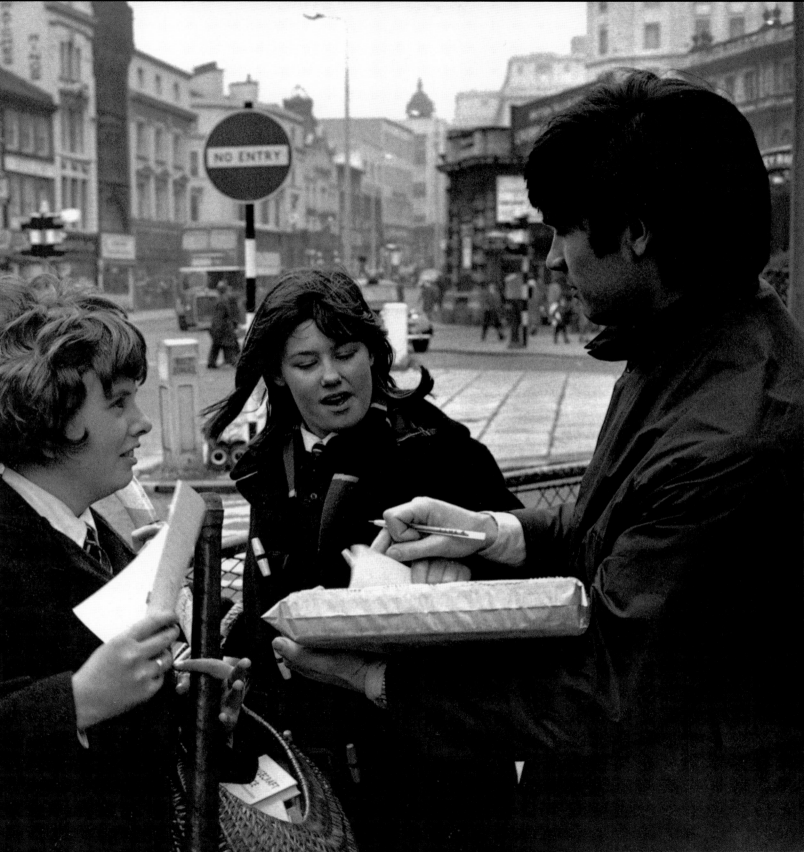

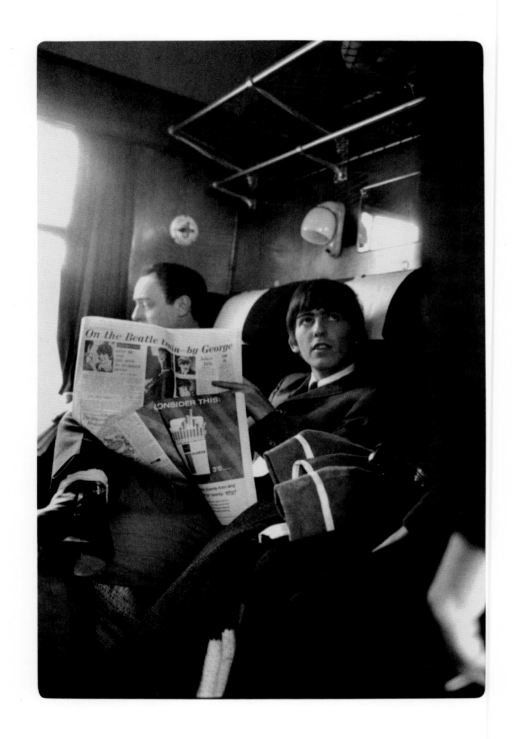

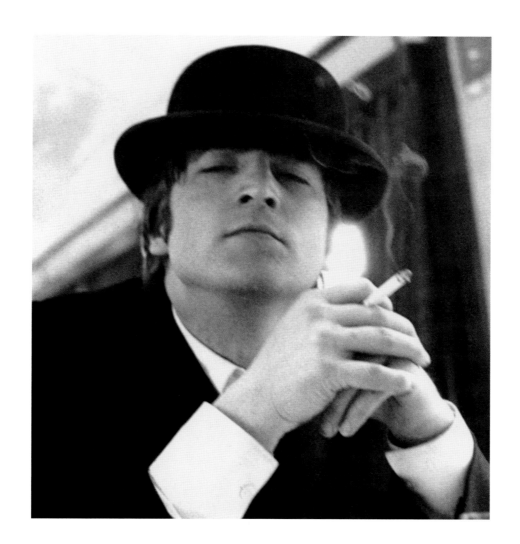

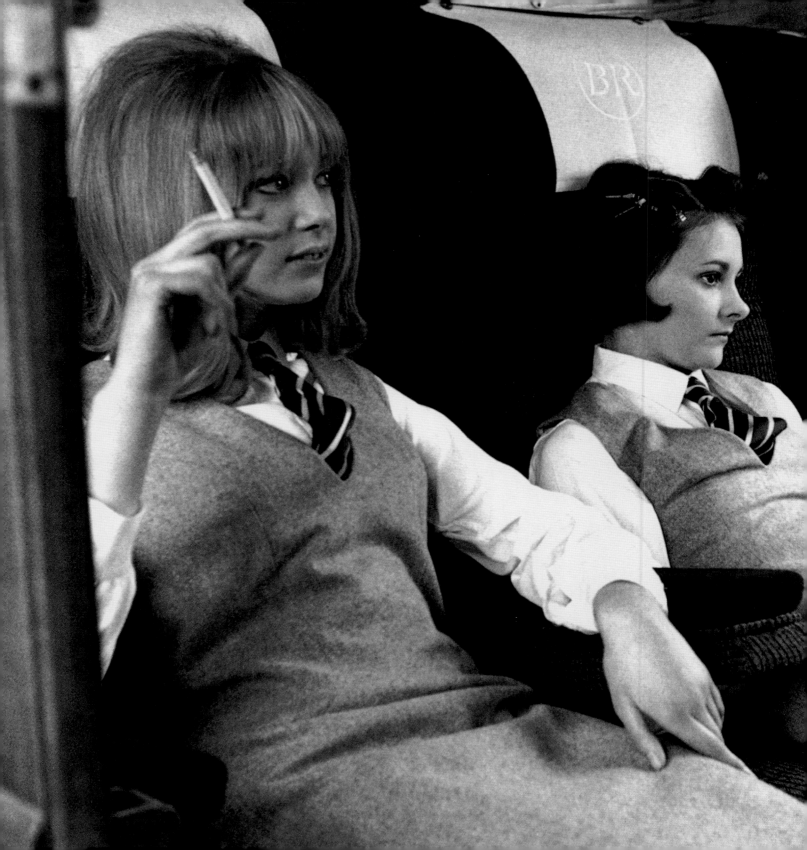

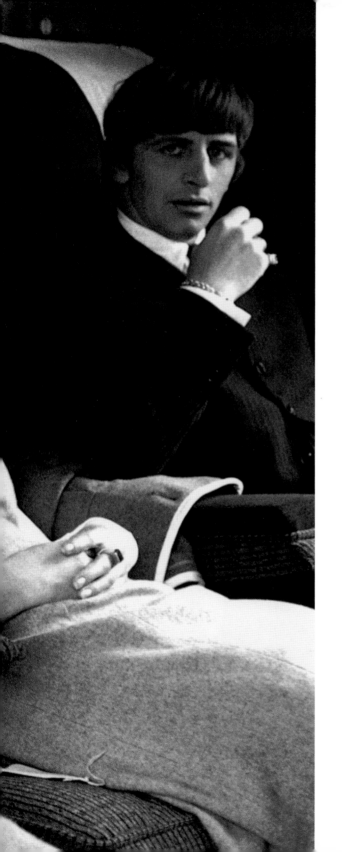

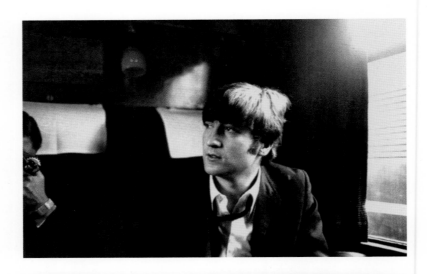

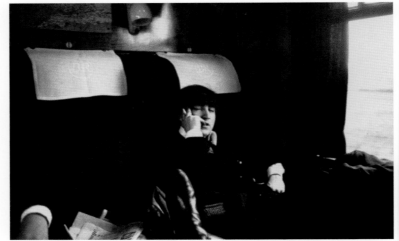

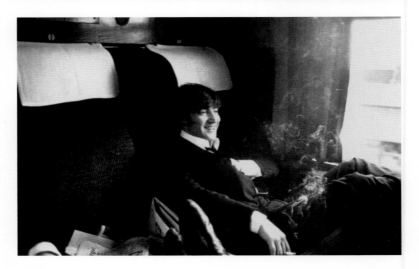

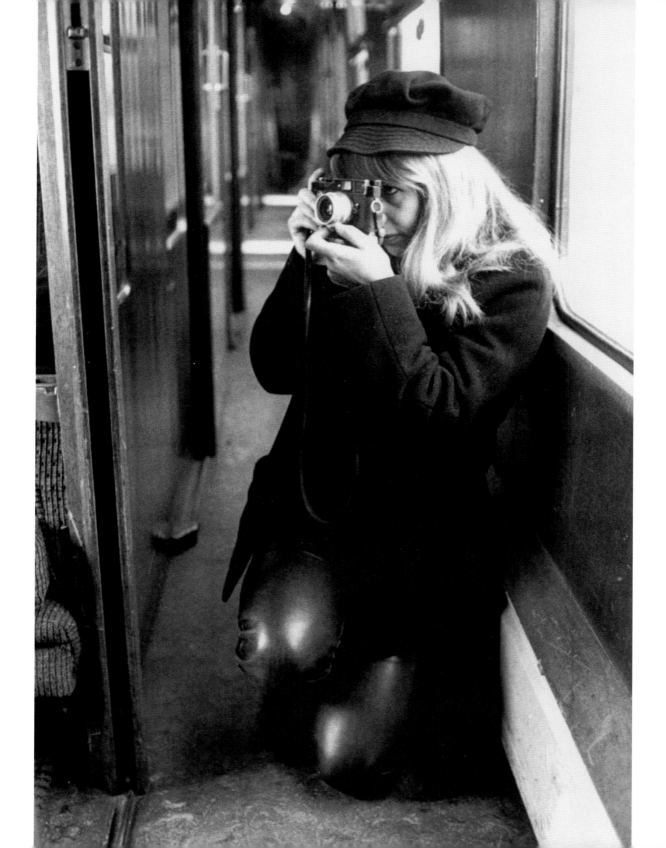

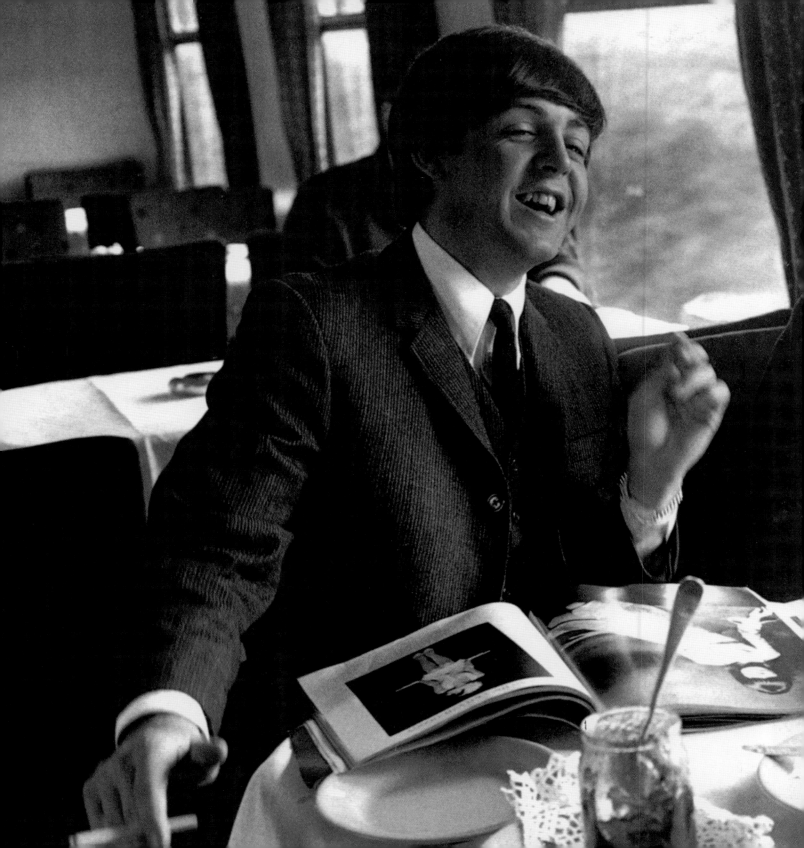

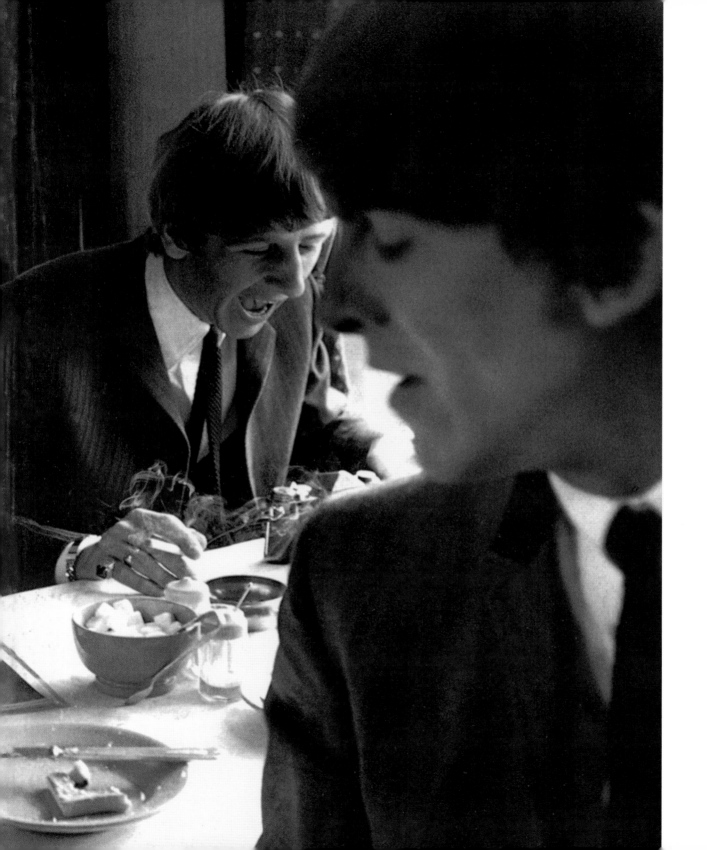

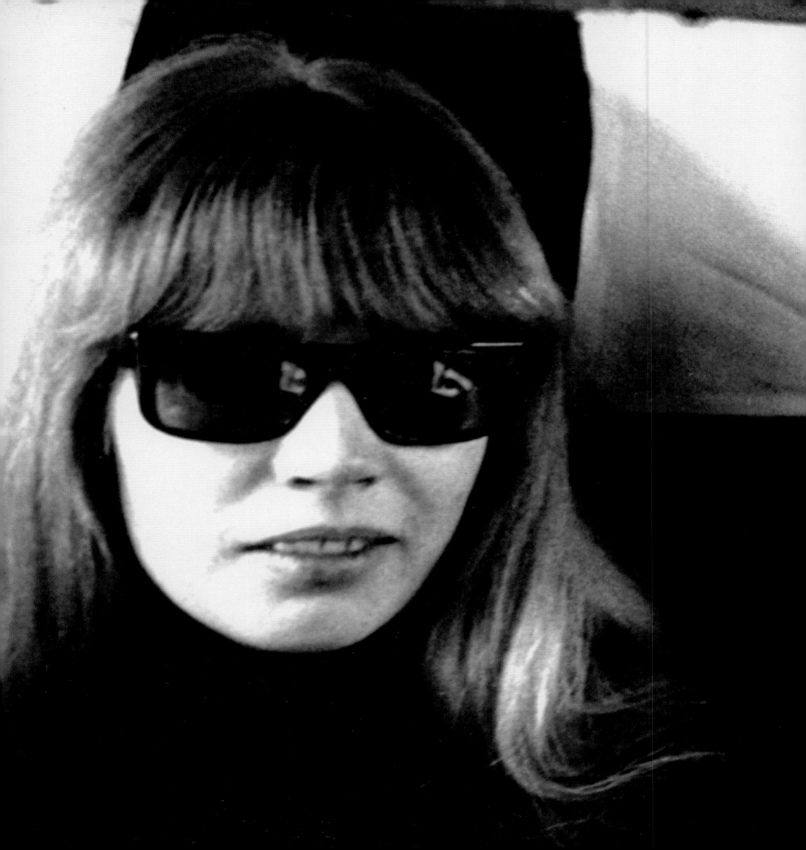

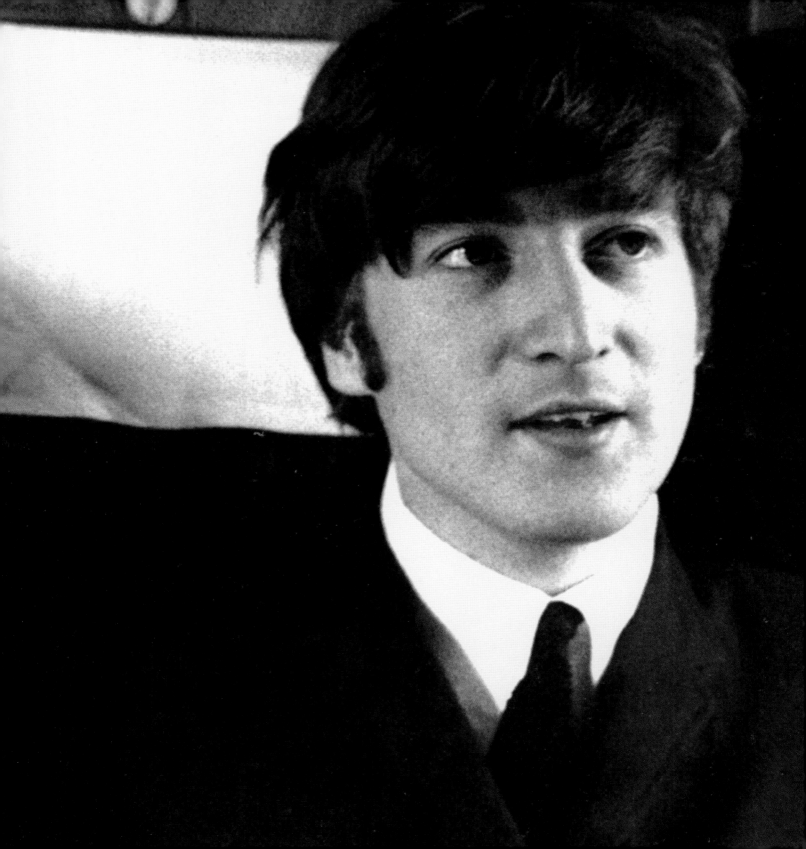

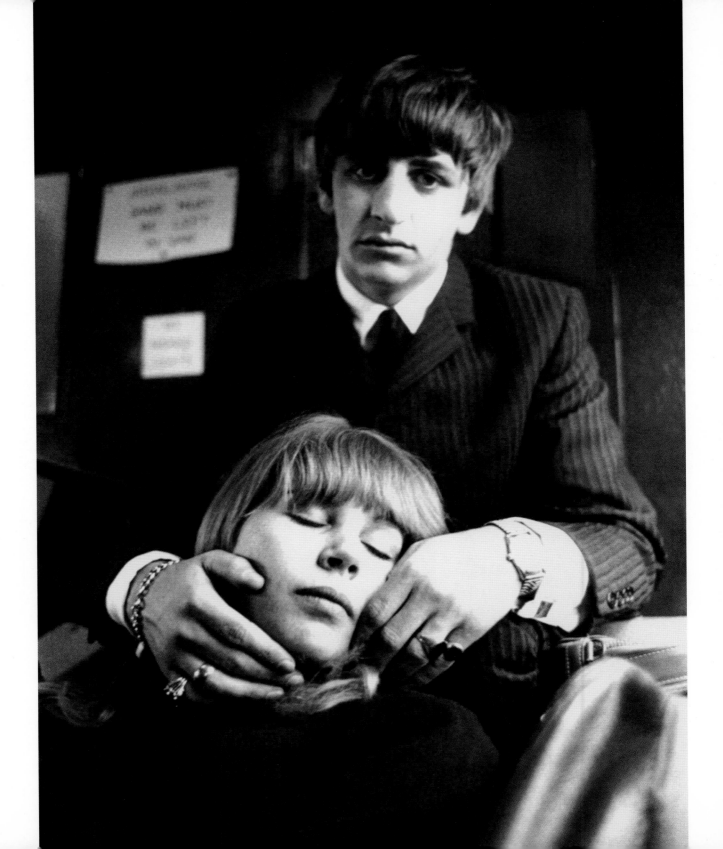

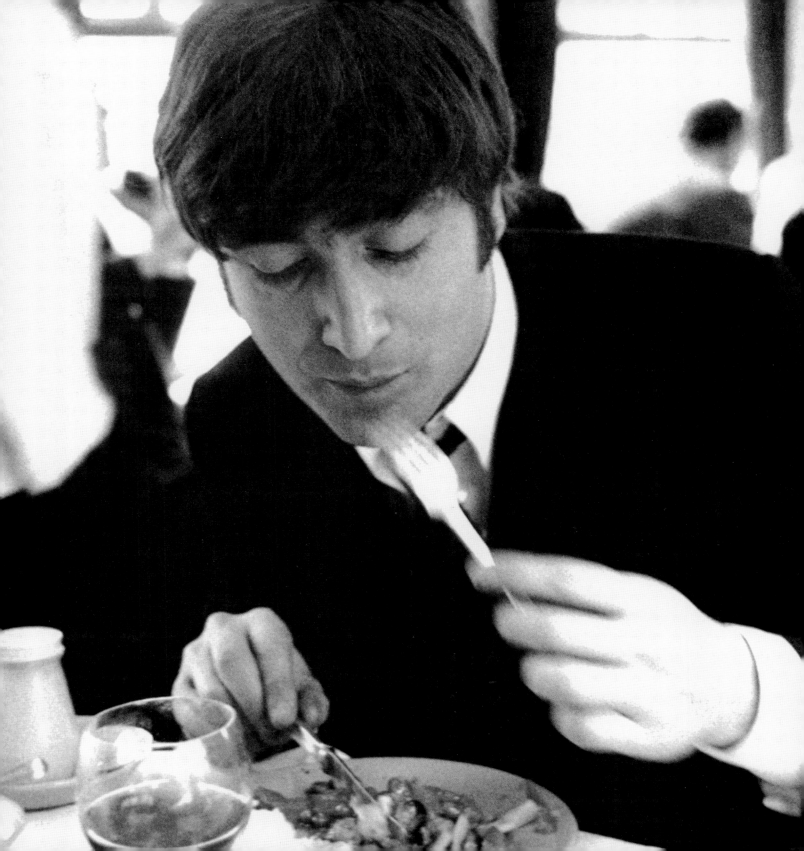

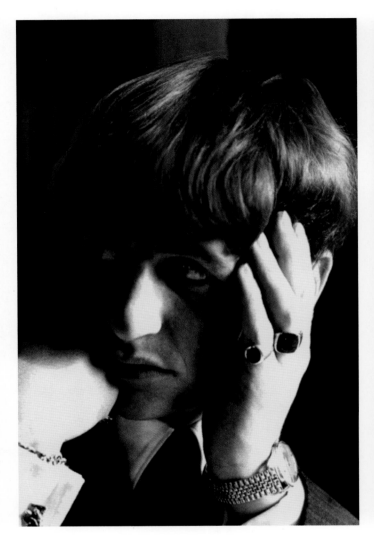
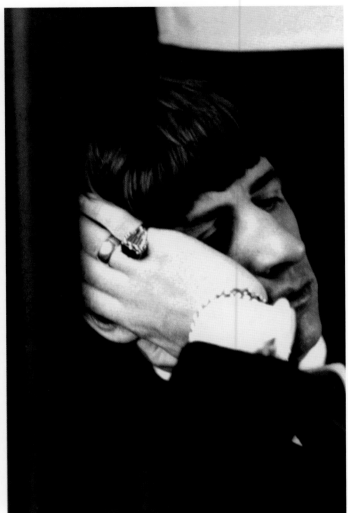

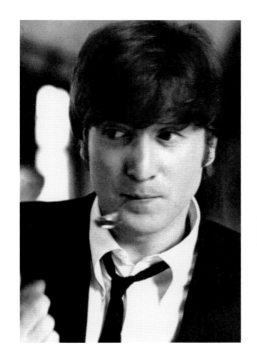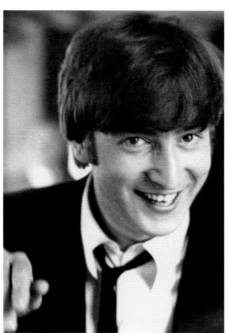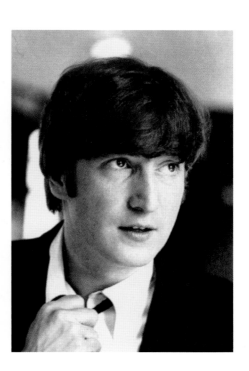

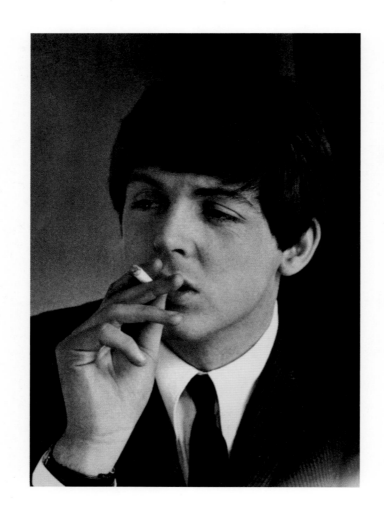

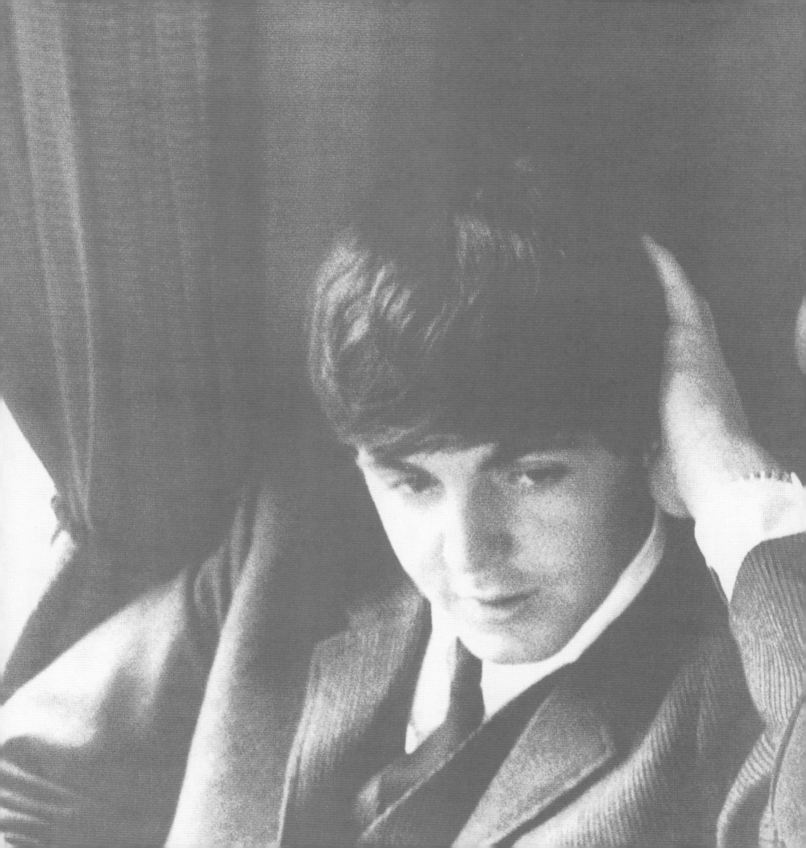

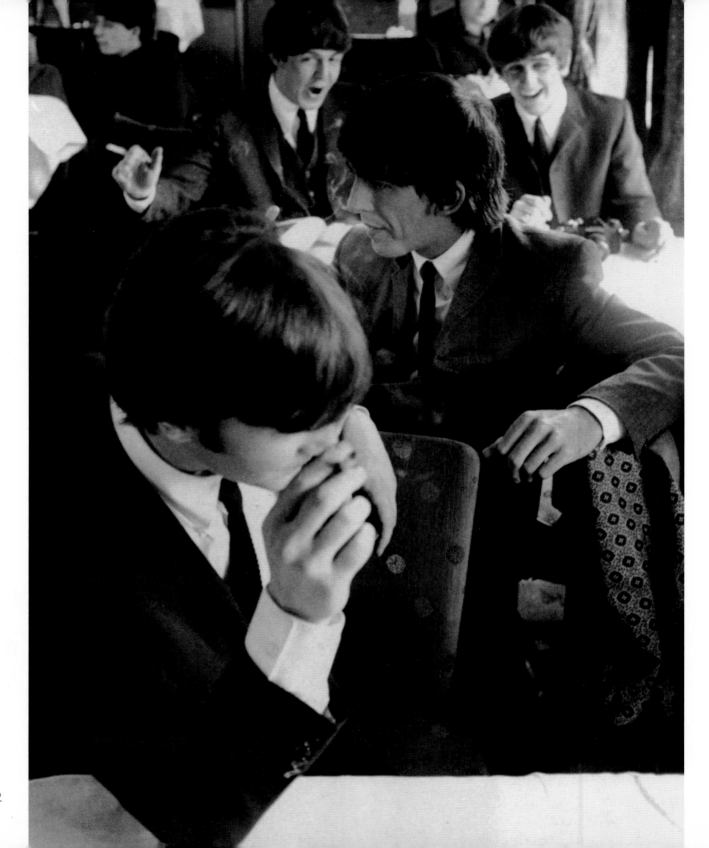

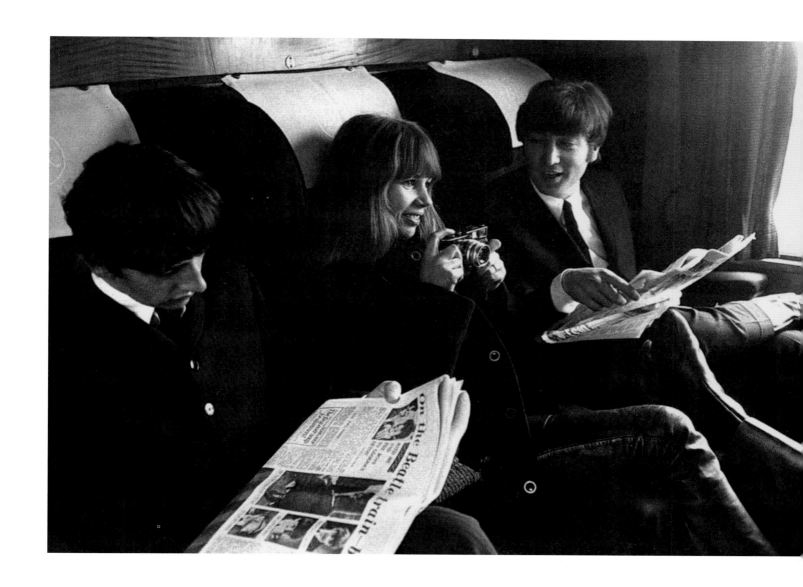

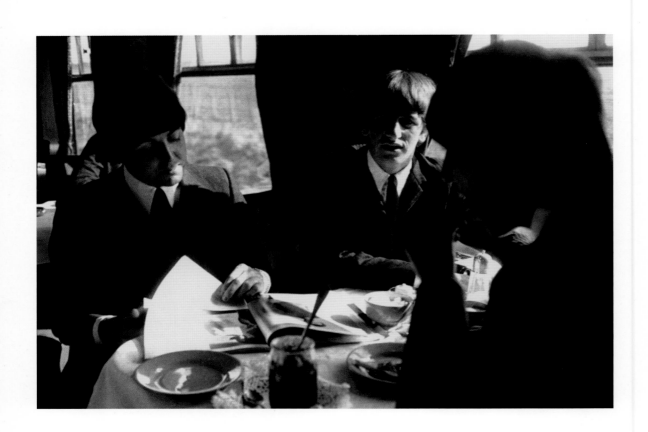

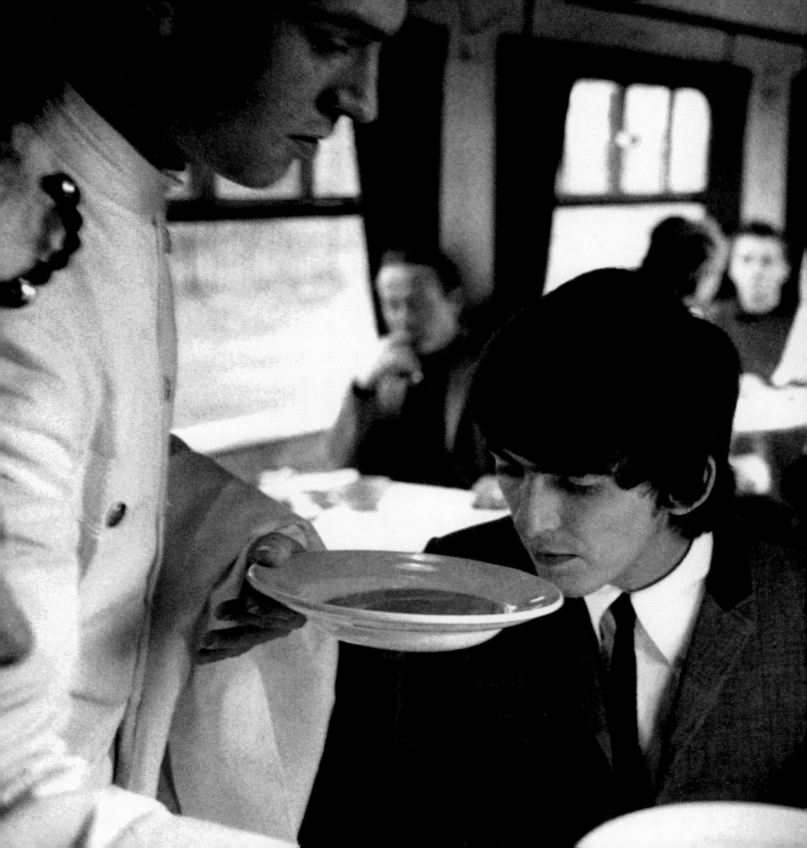

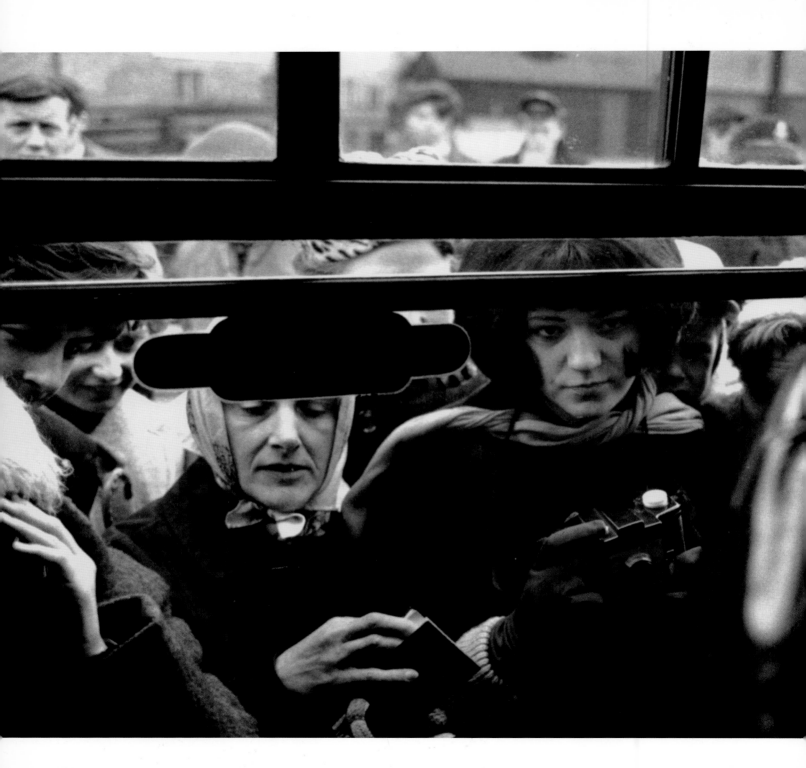

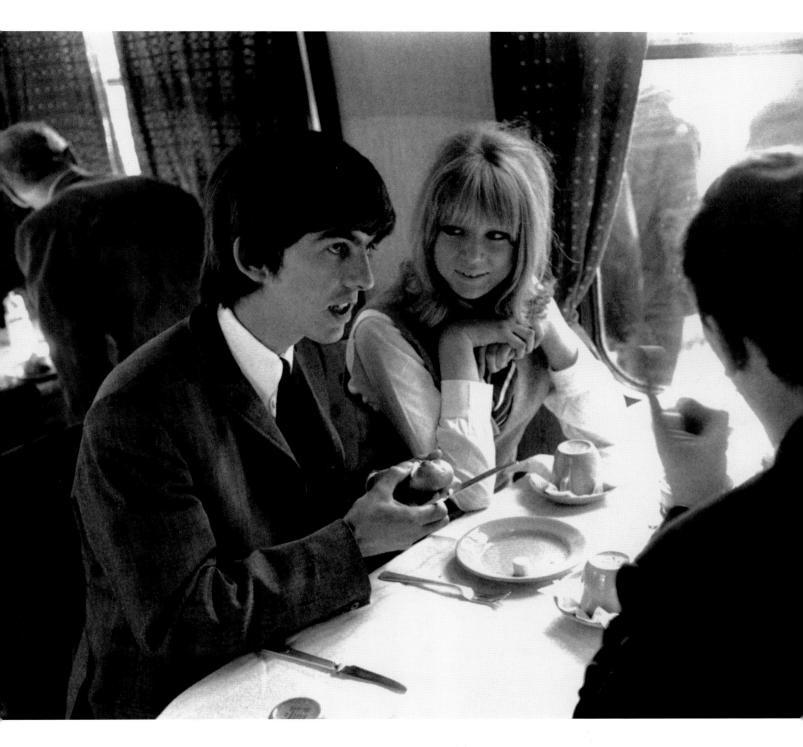

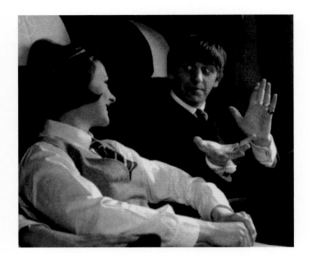

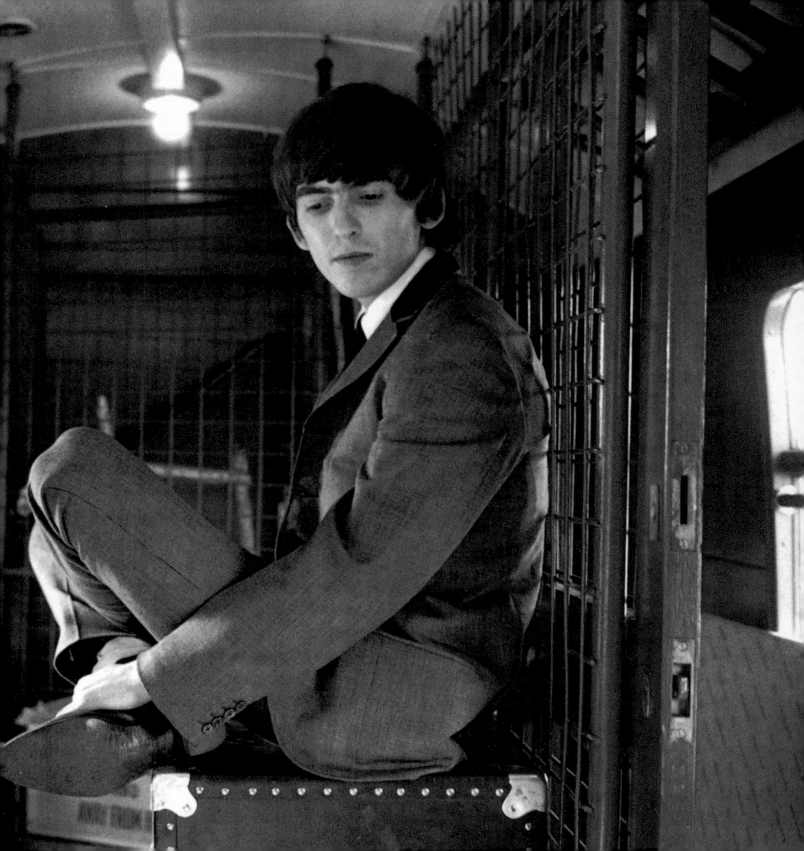

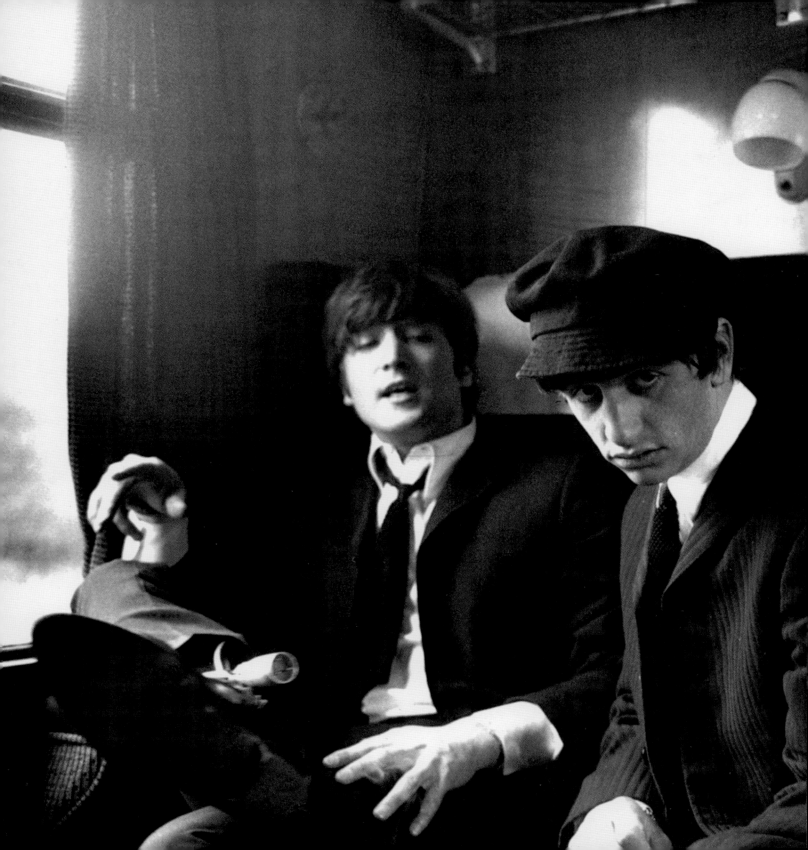

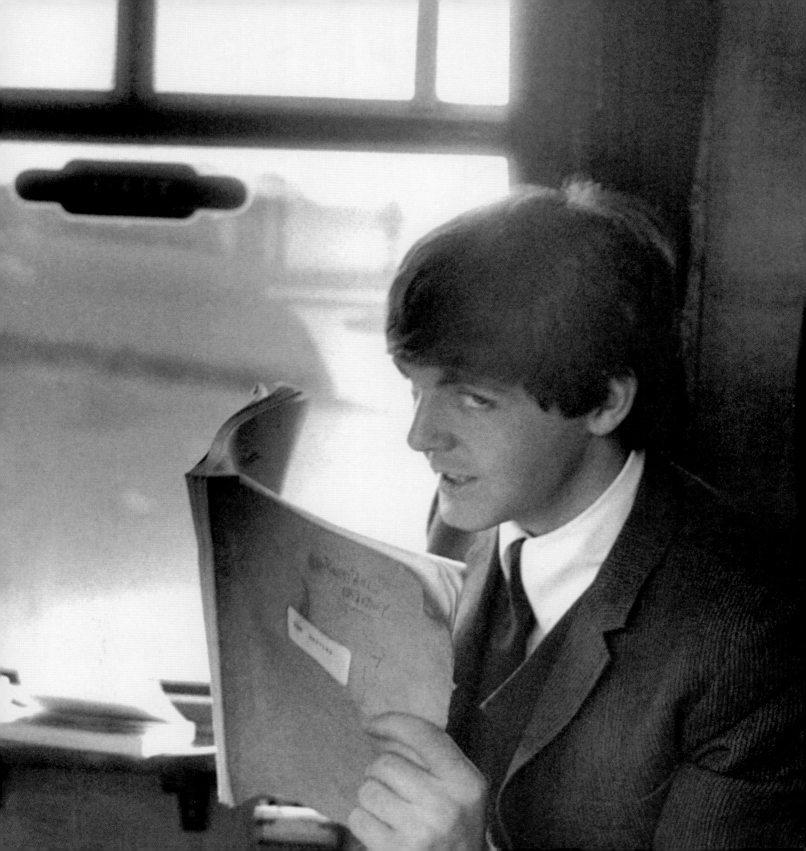

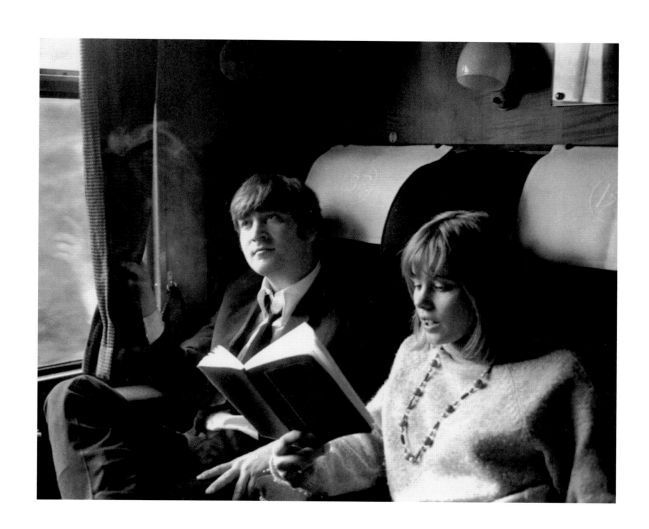

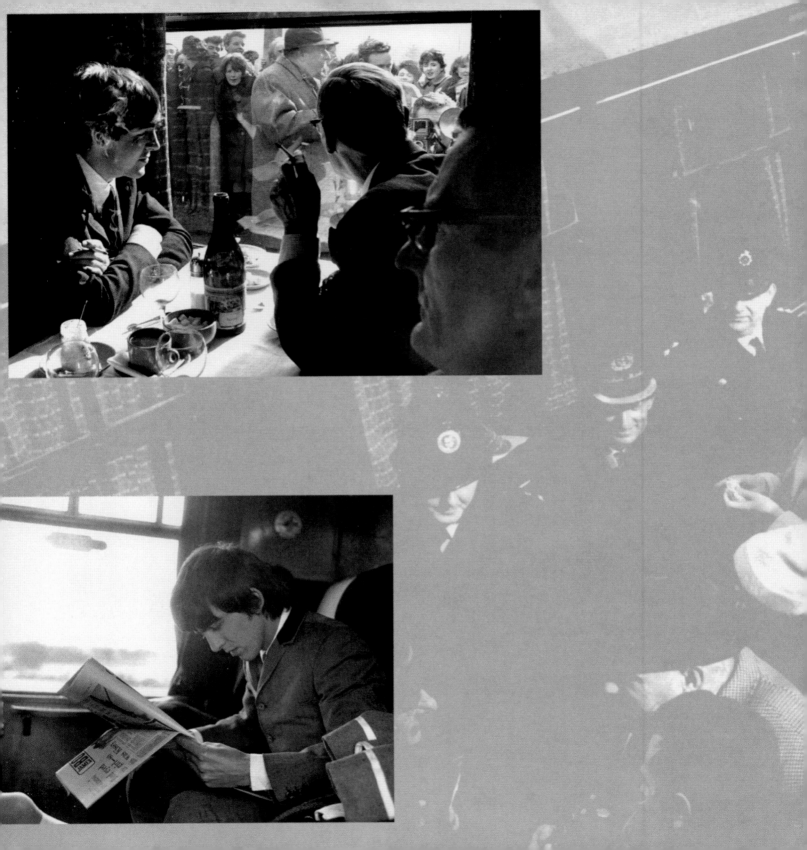

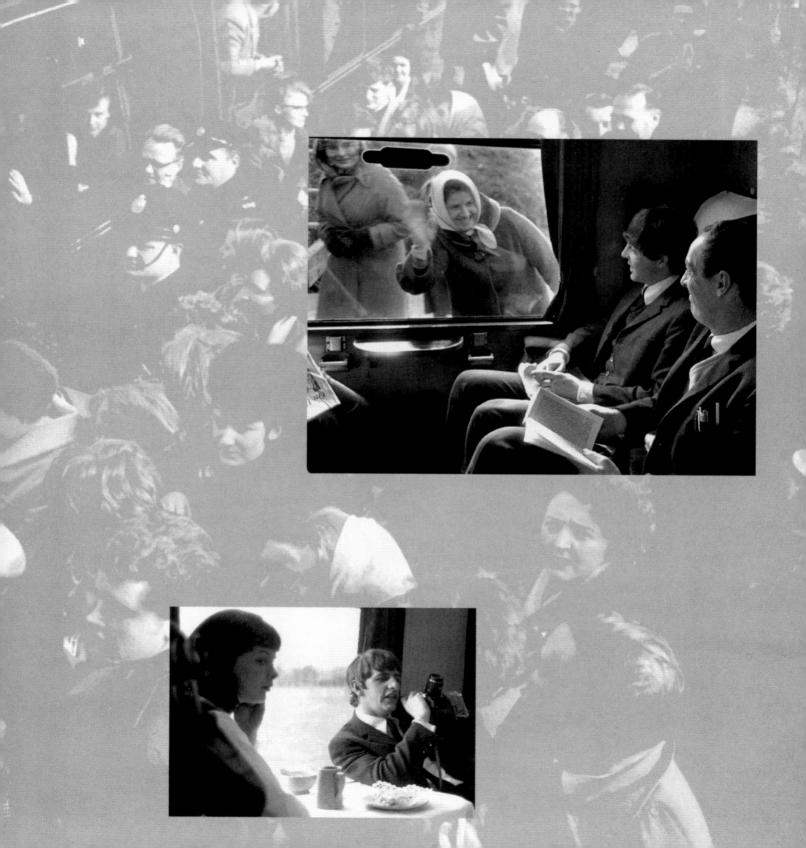

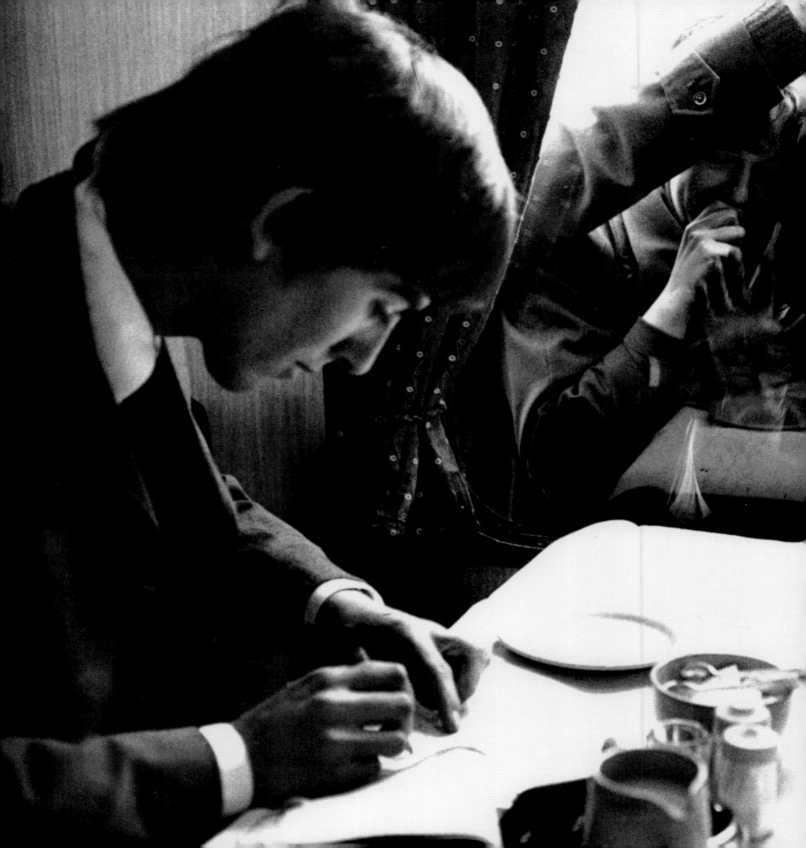

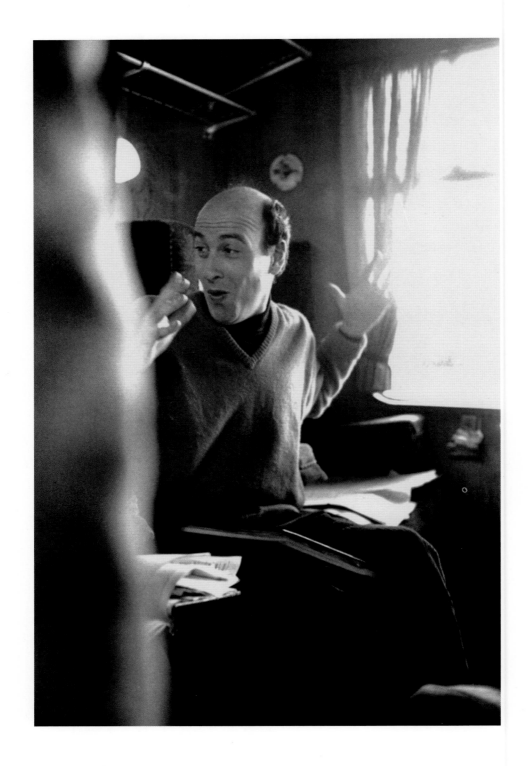

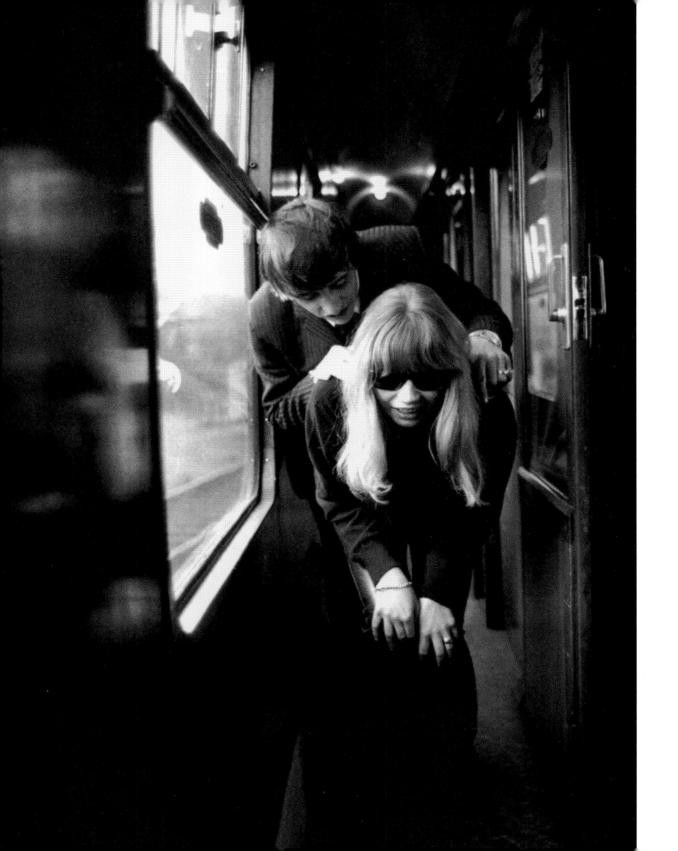

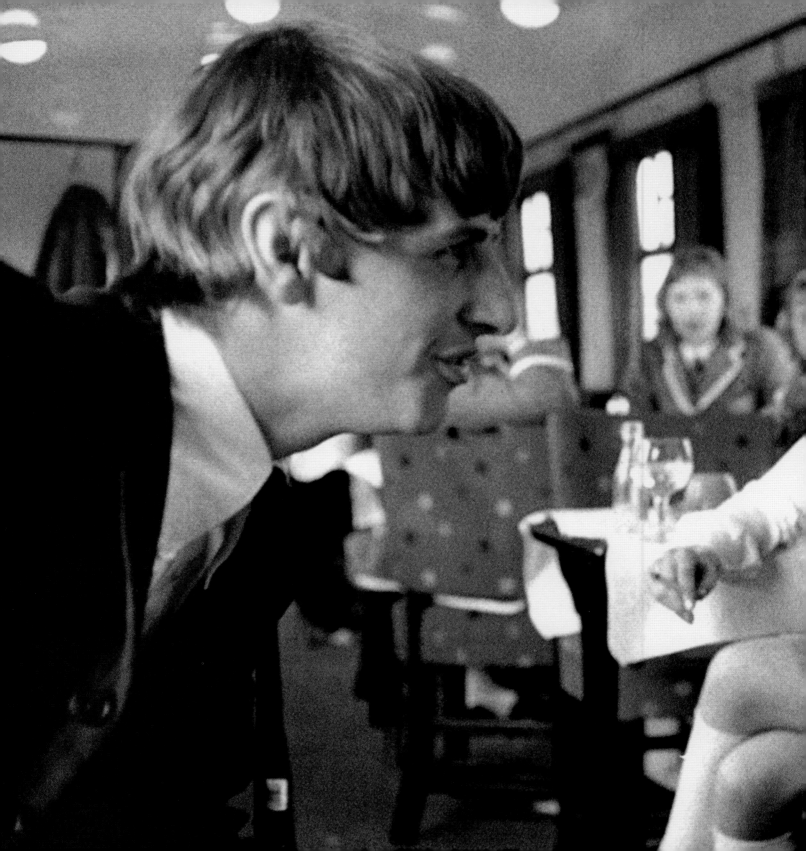

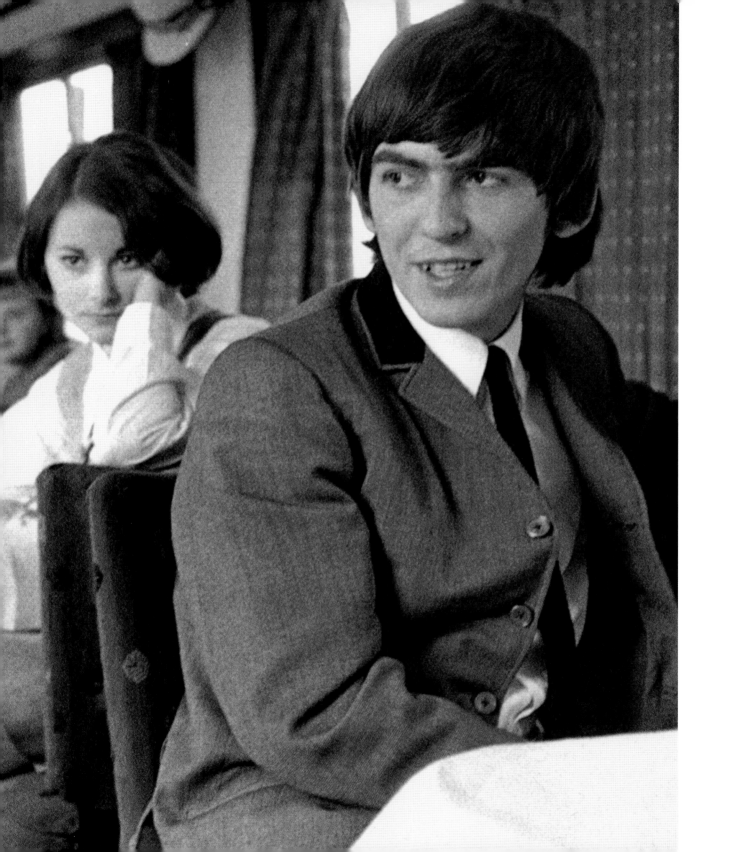

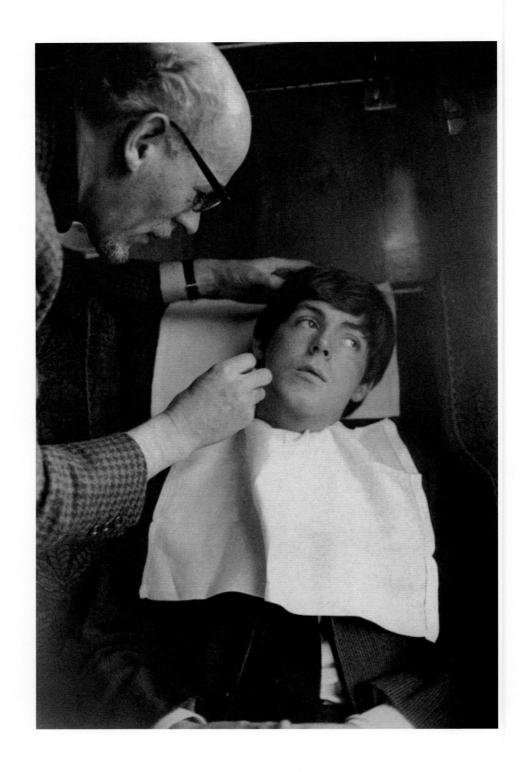

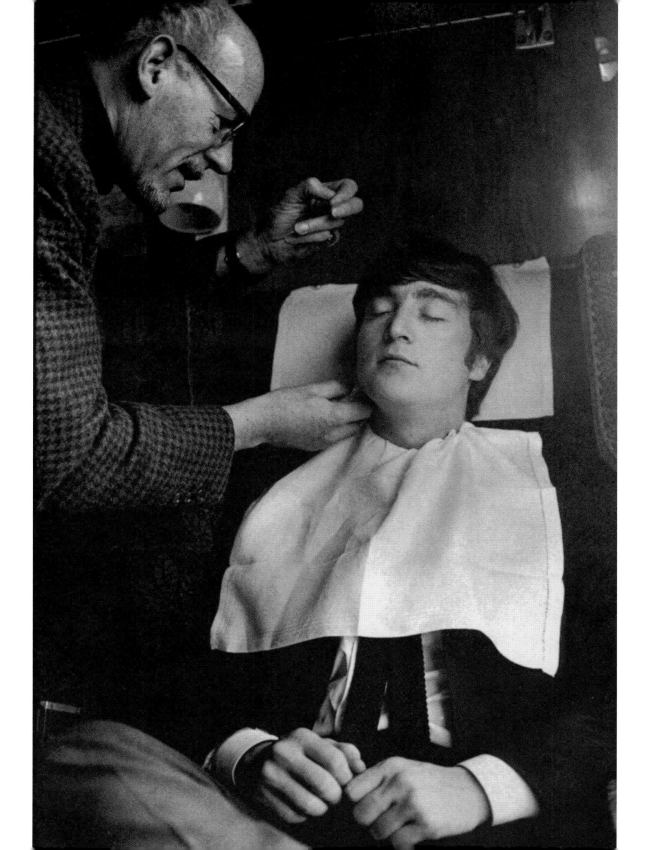

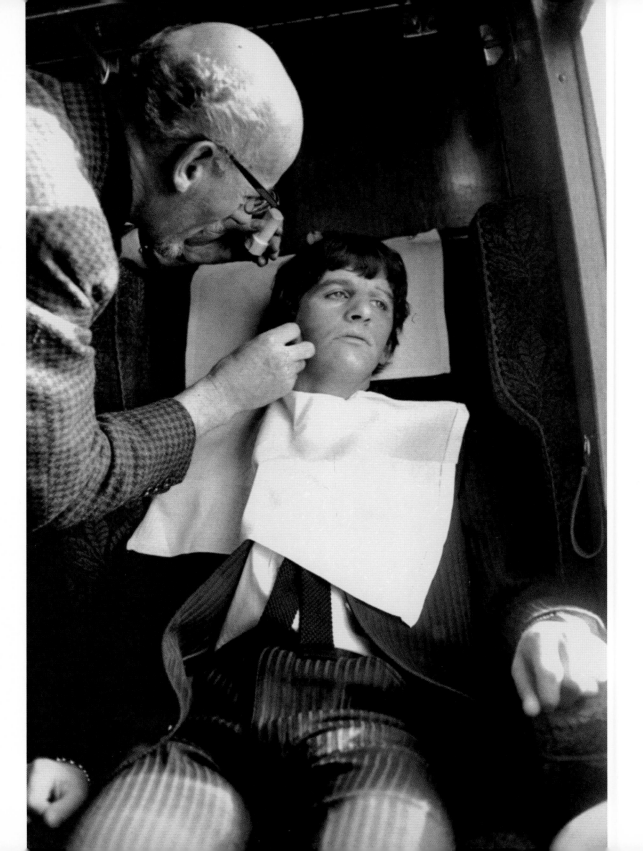

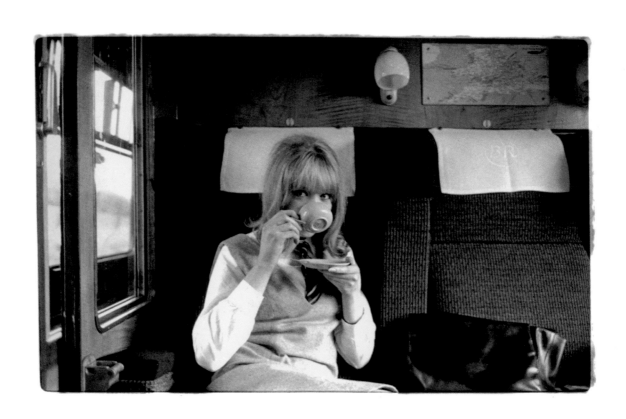

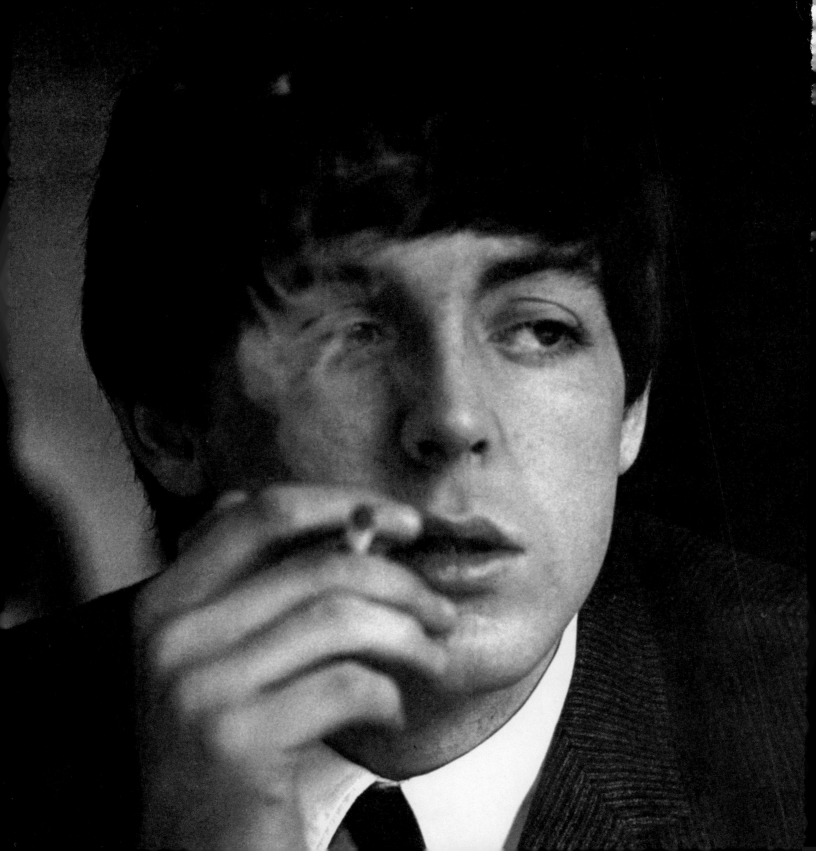

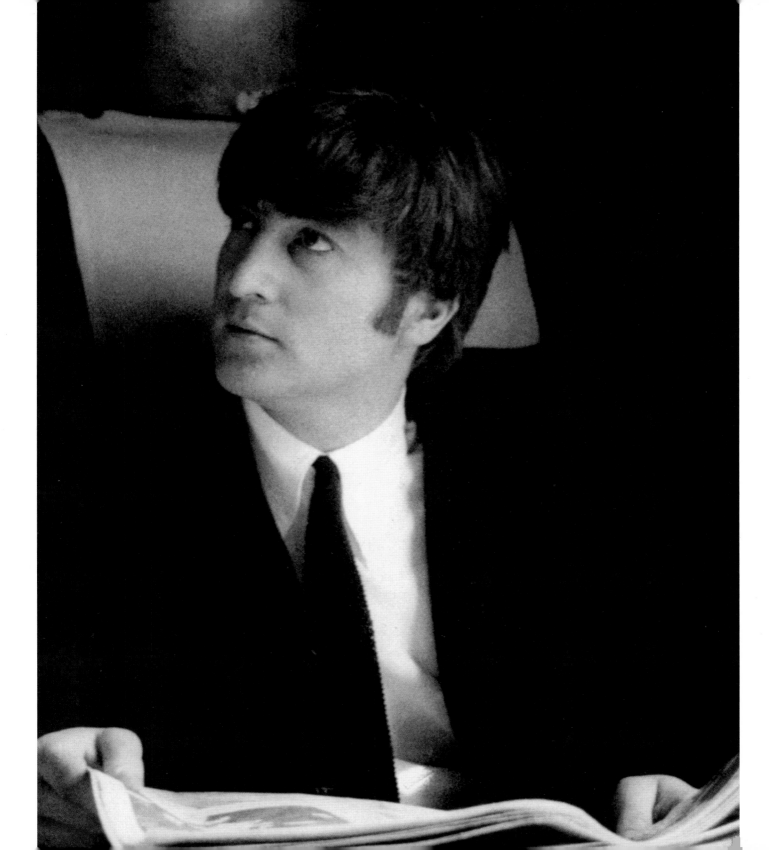

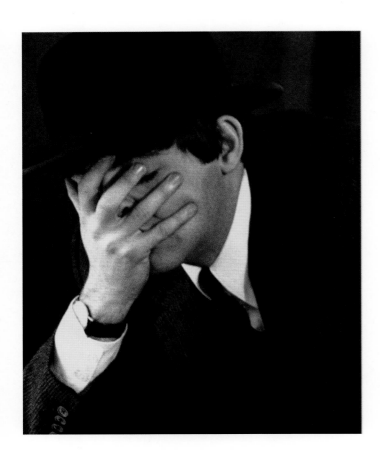

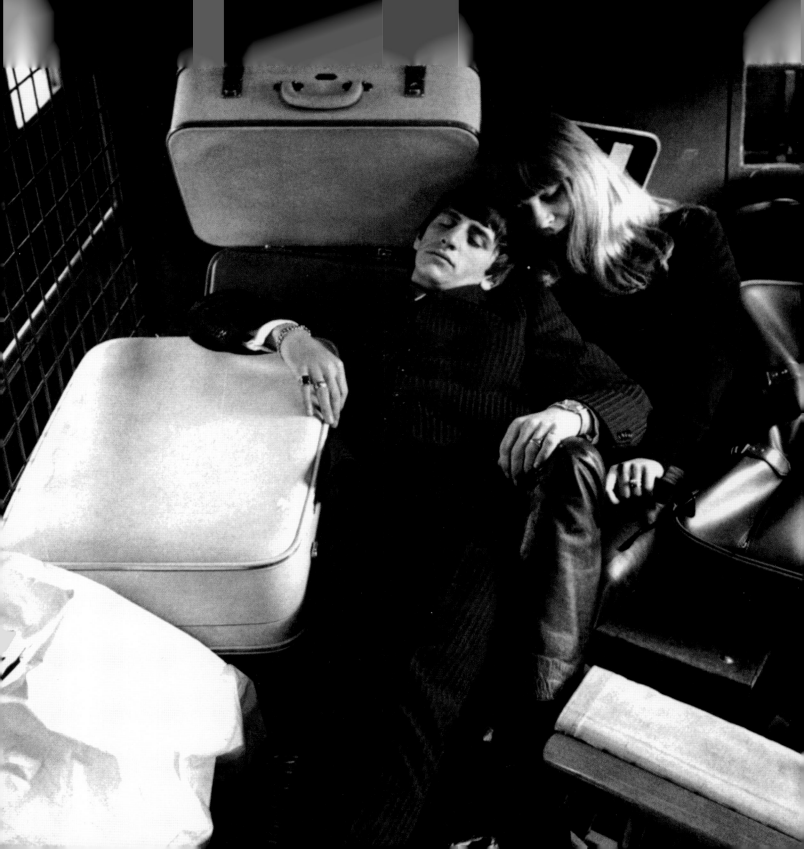

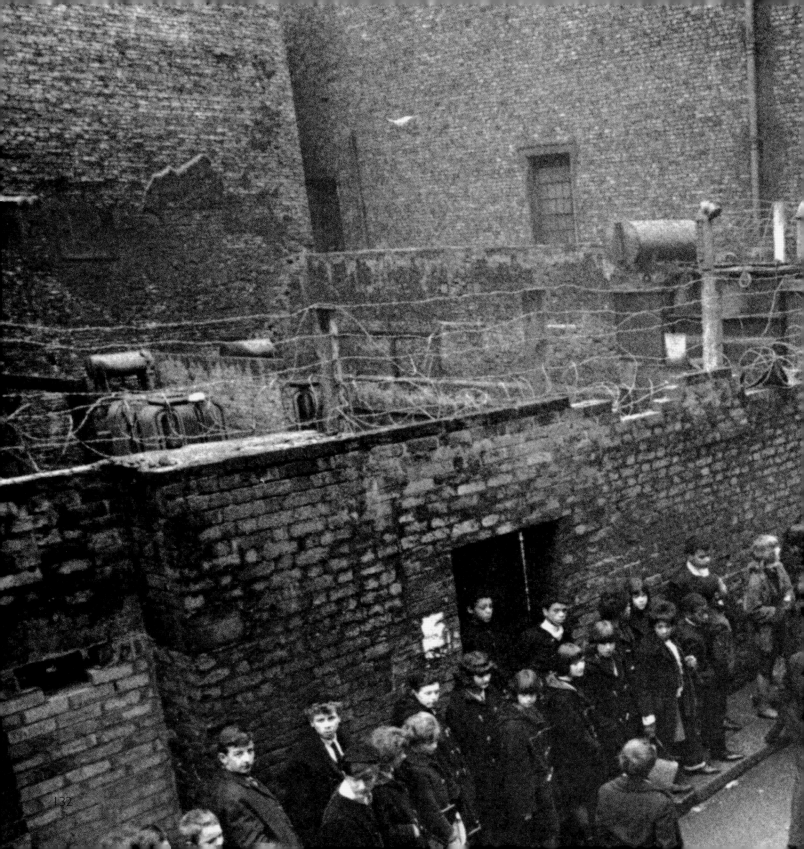

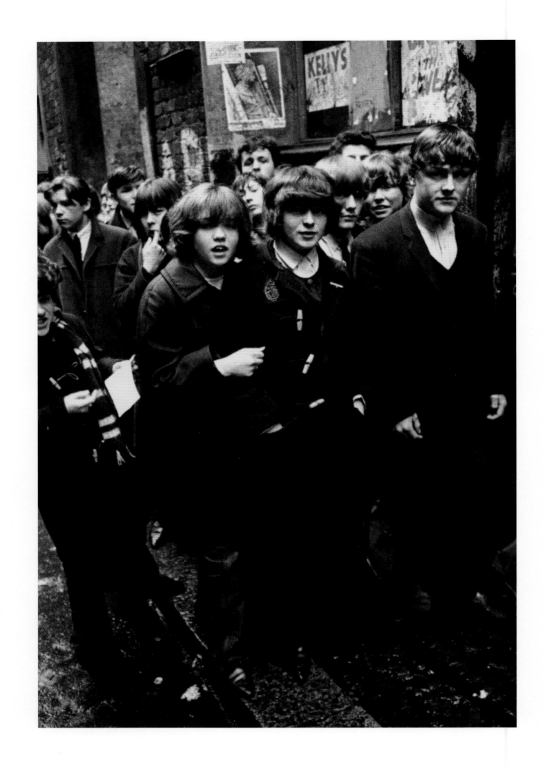

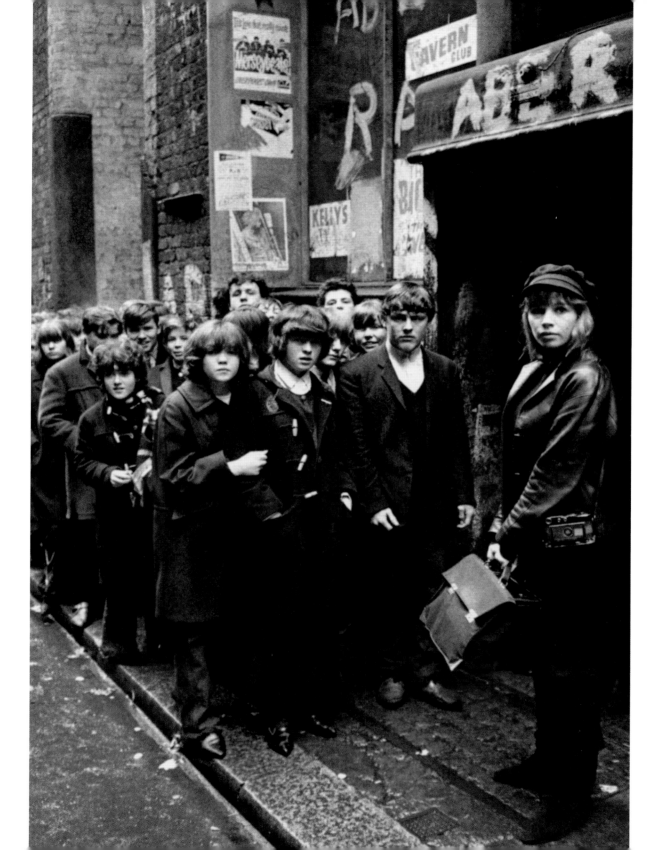

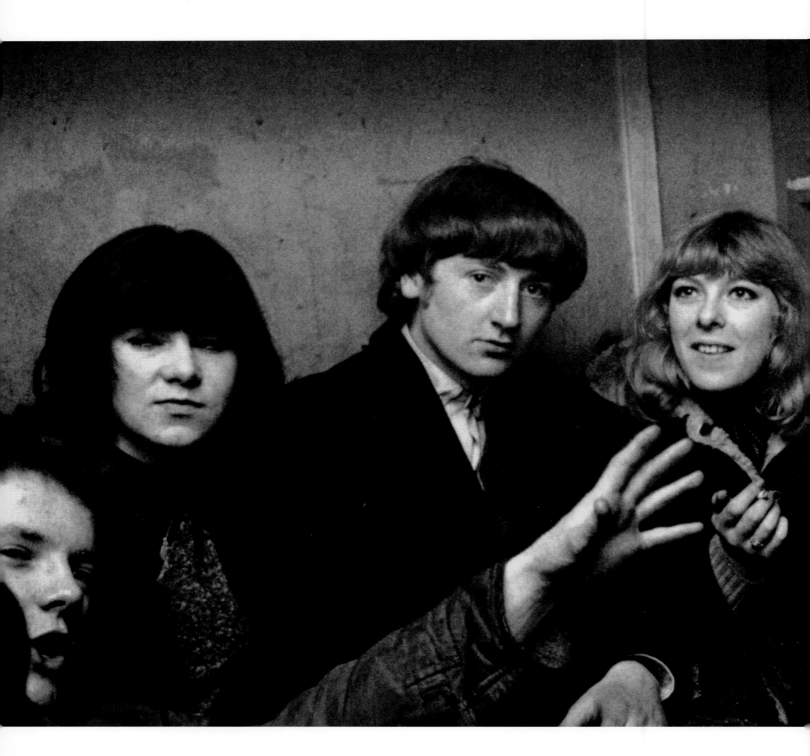

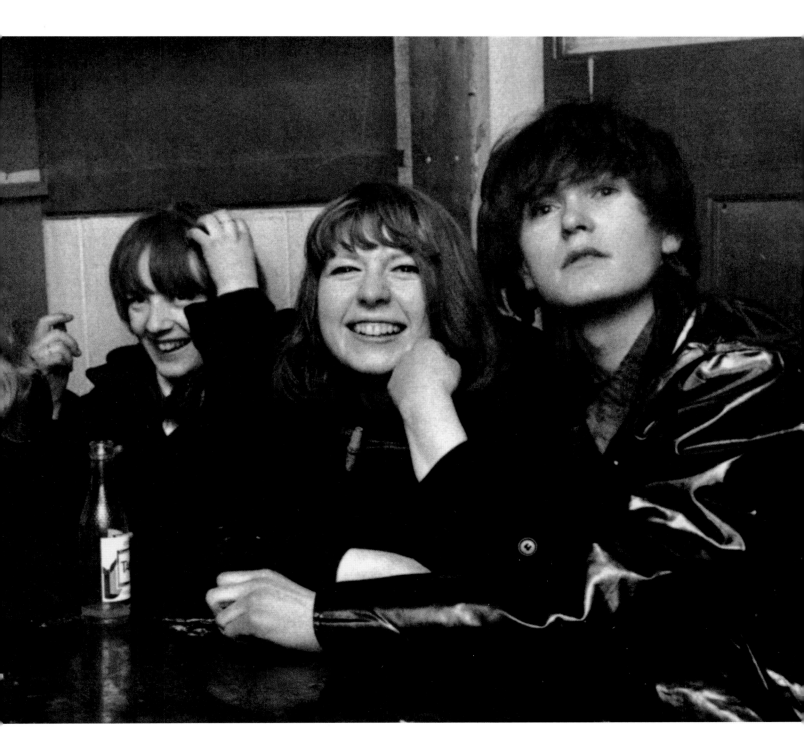

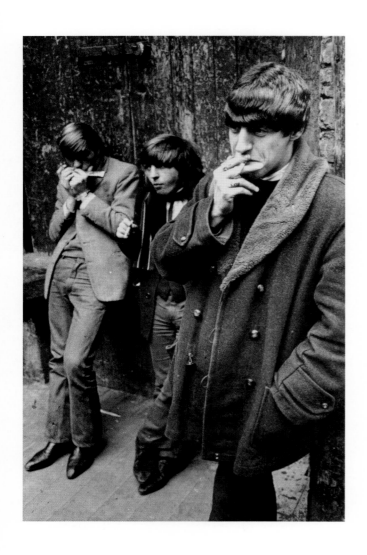

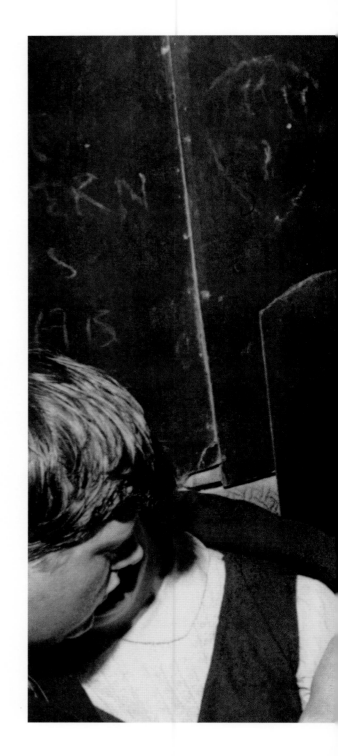

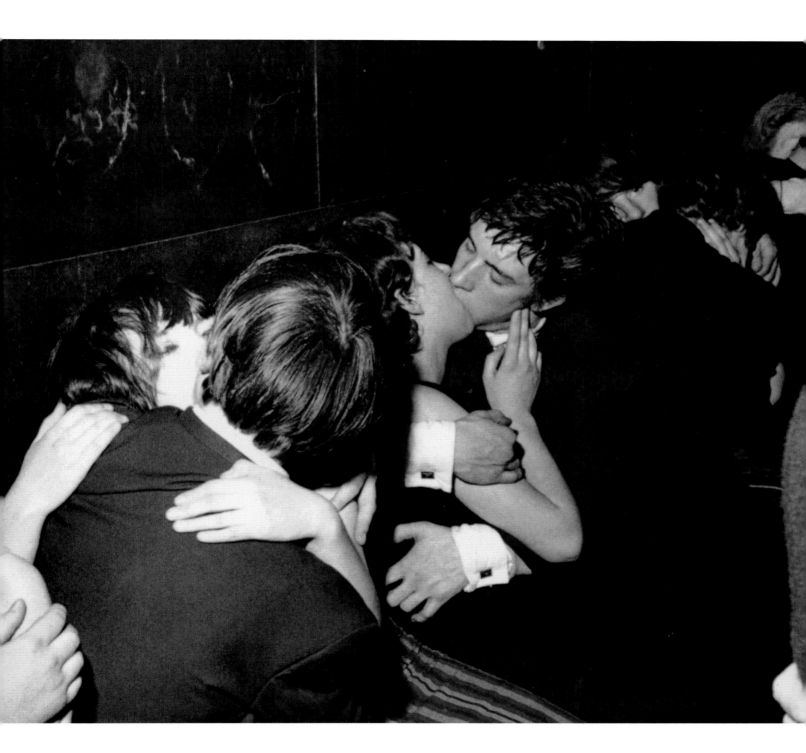

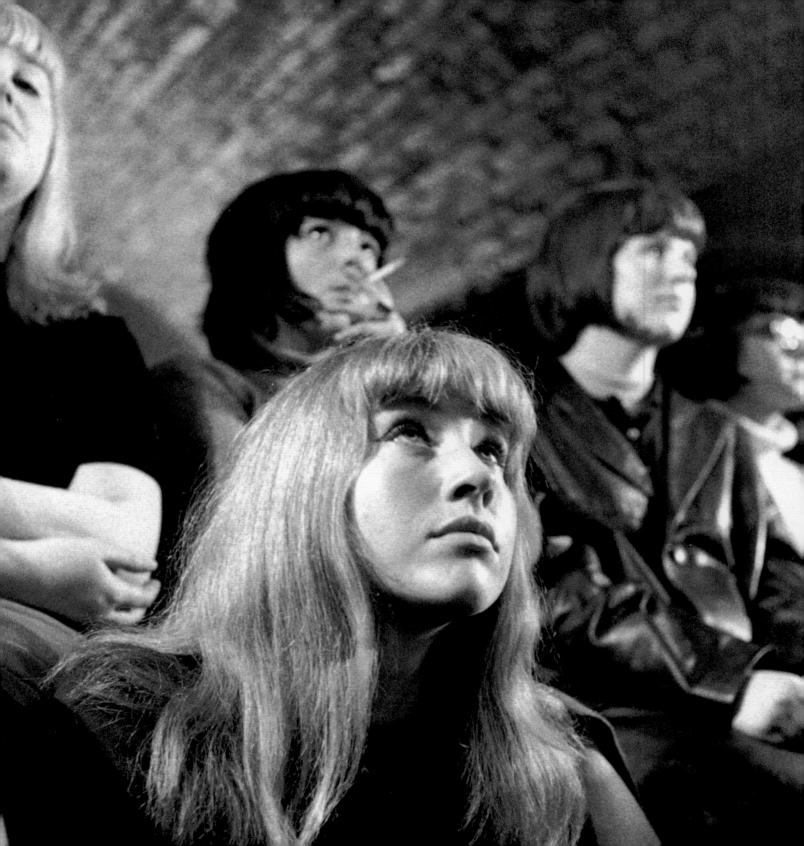

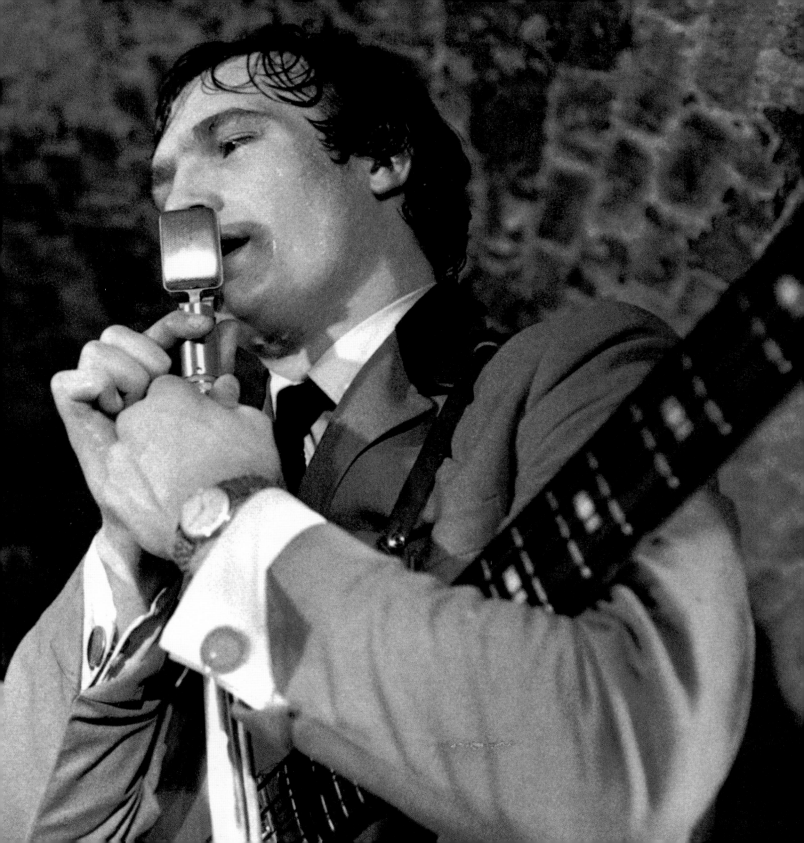

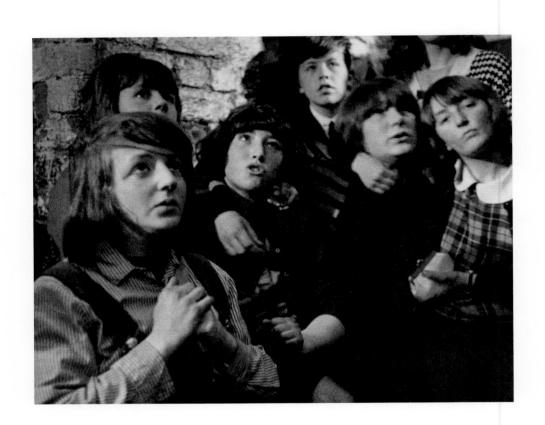

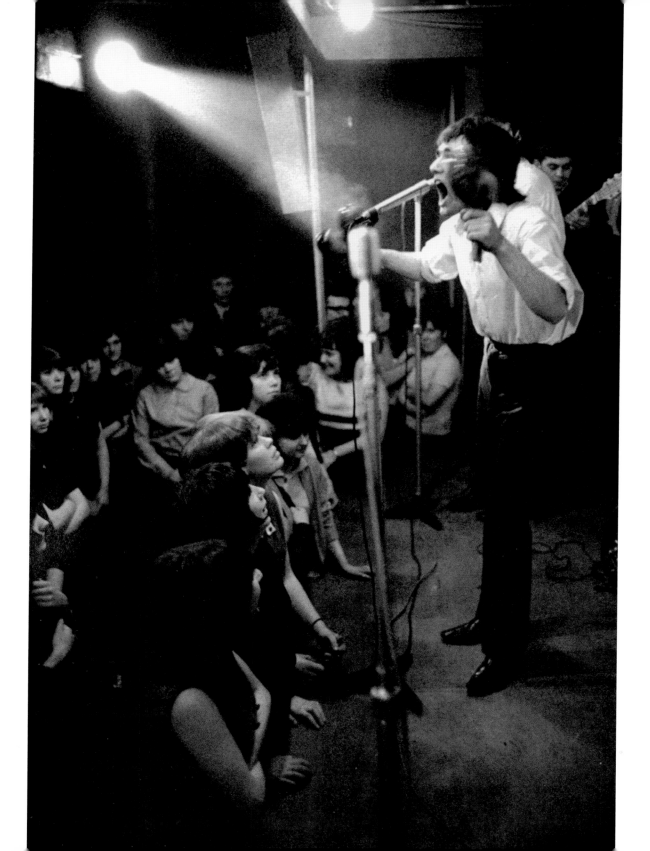

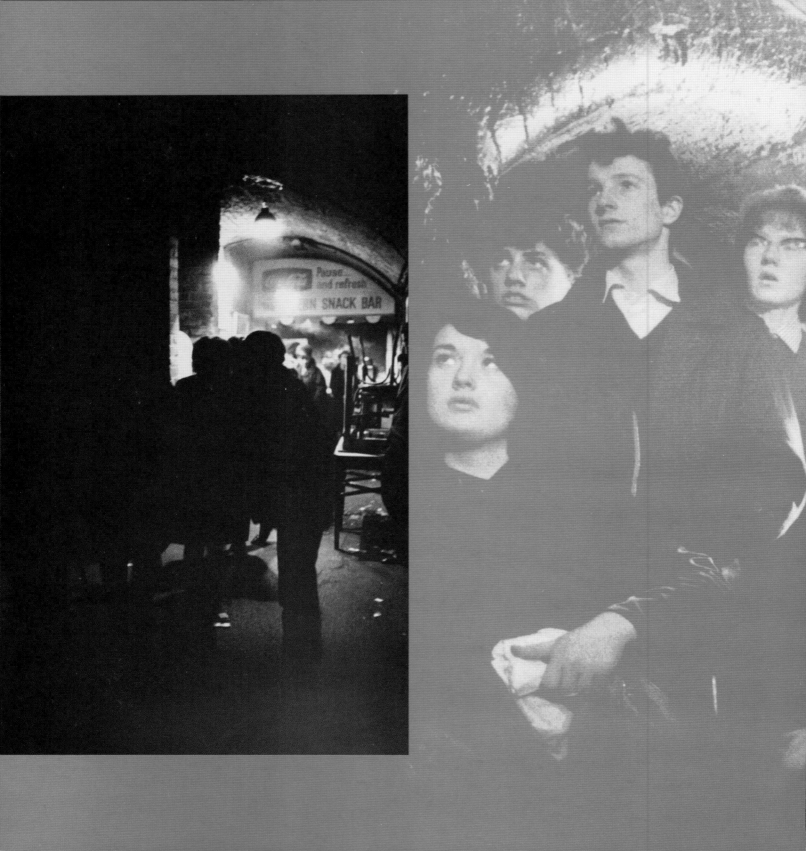

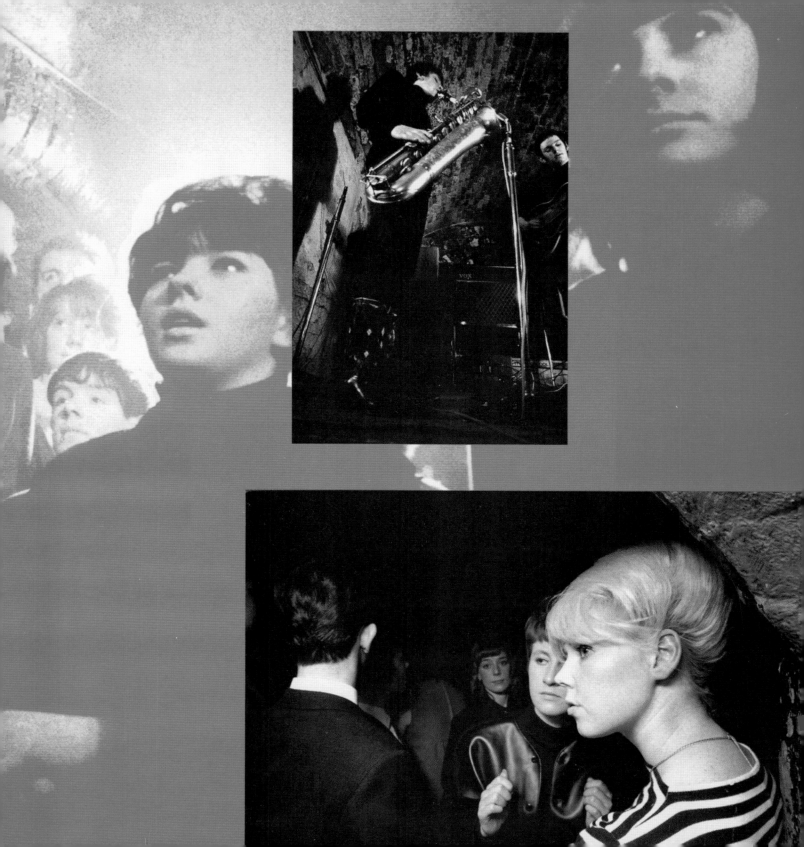

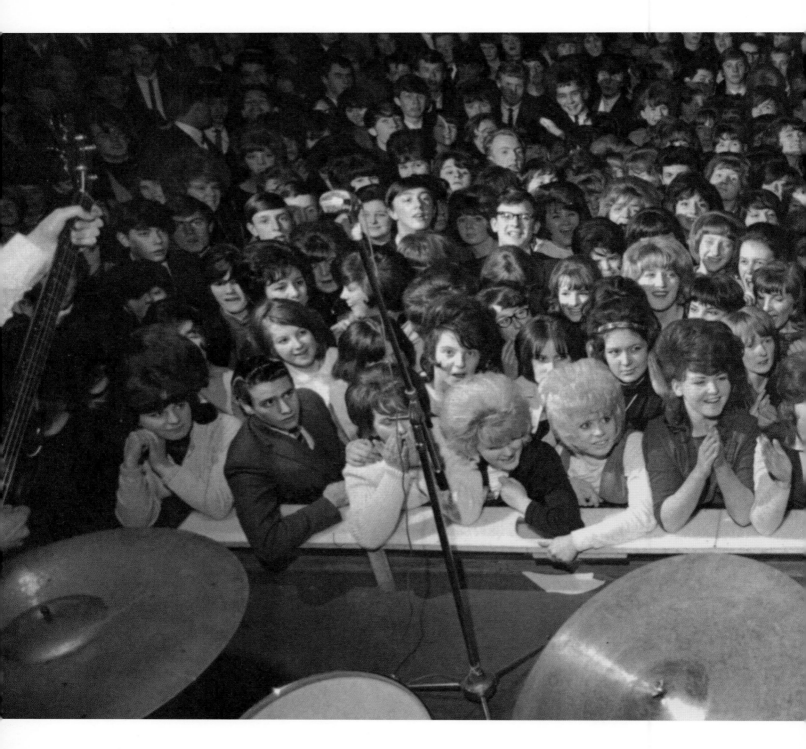

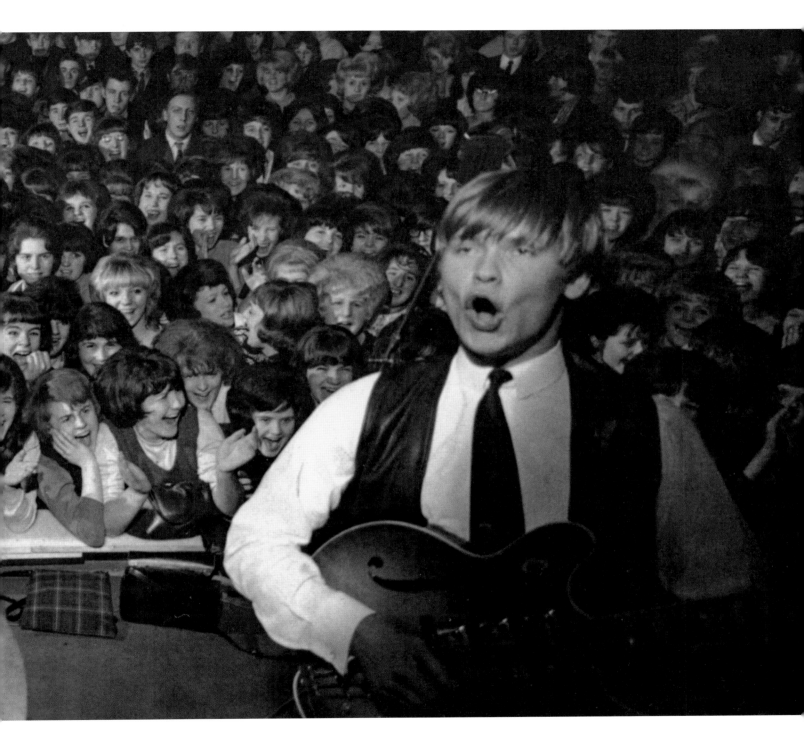

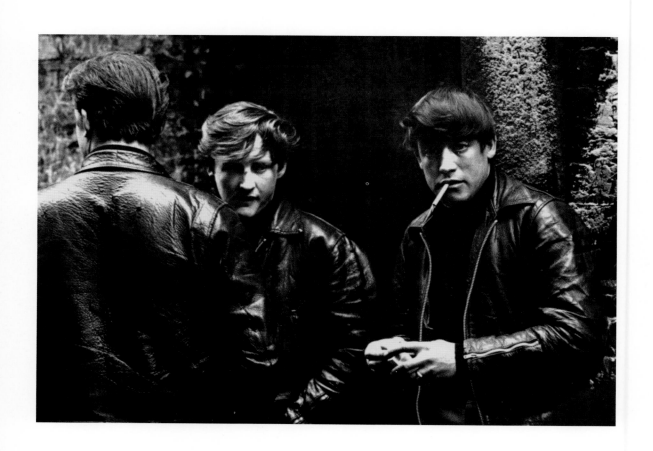

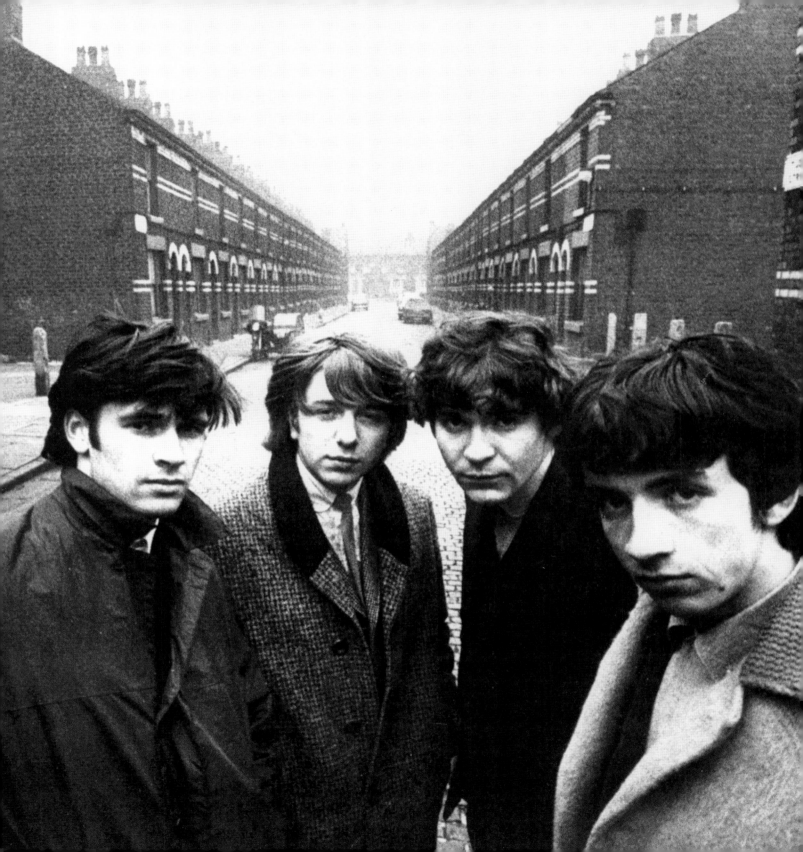

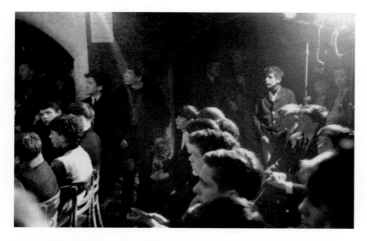

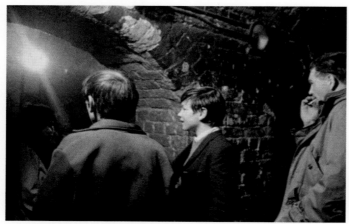

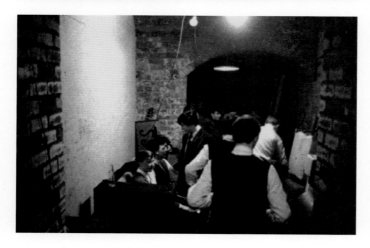

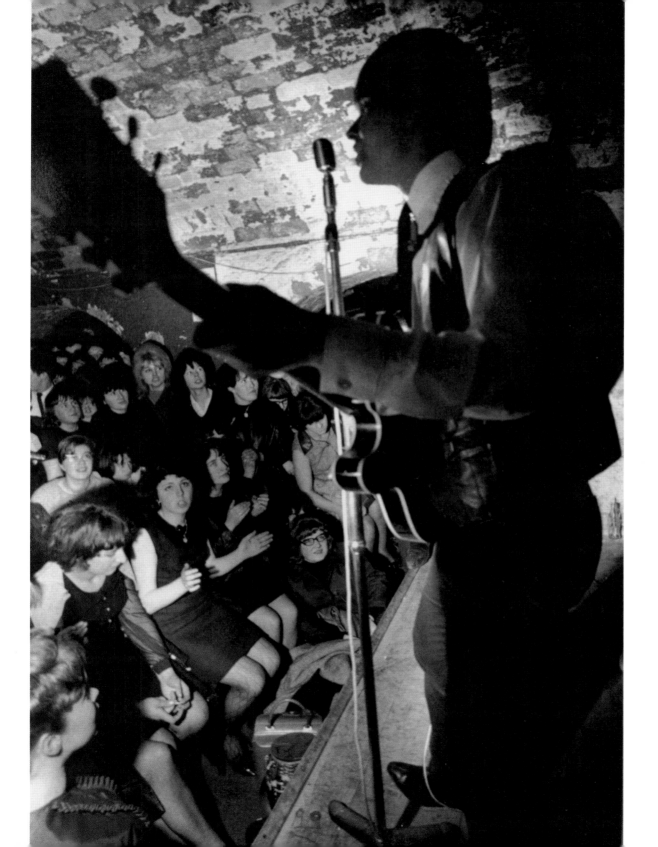

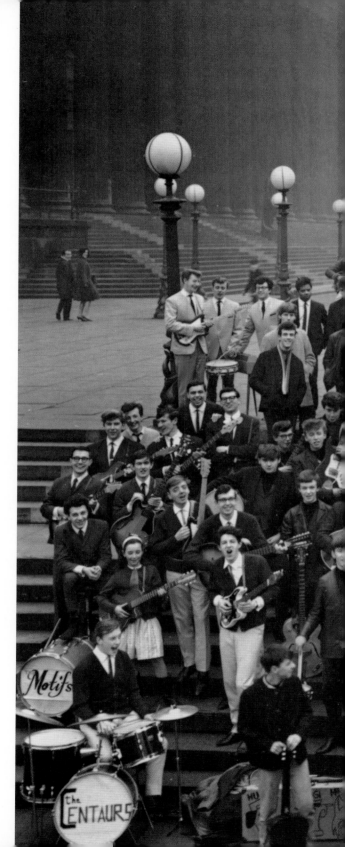

154

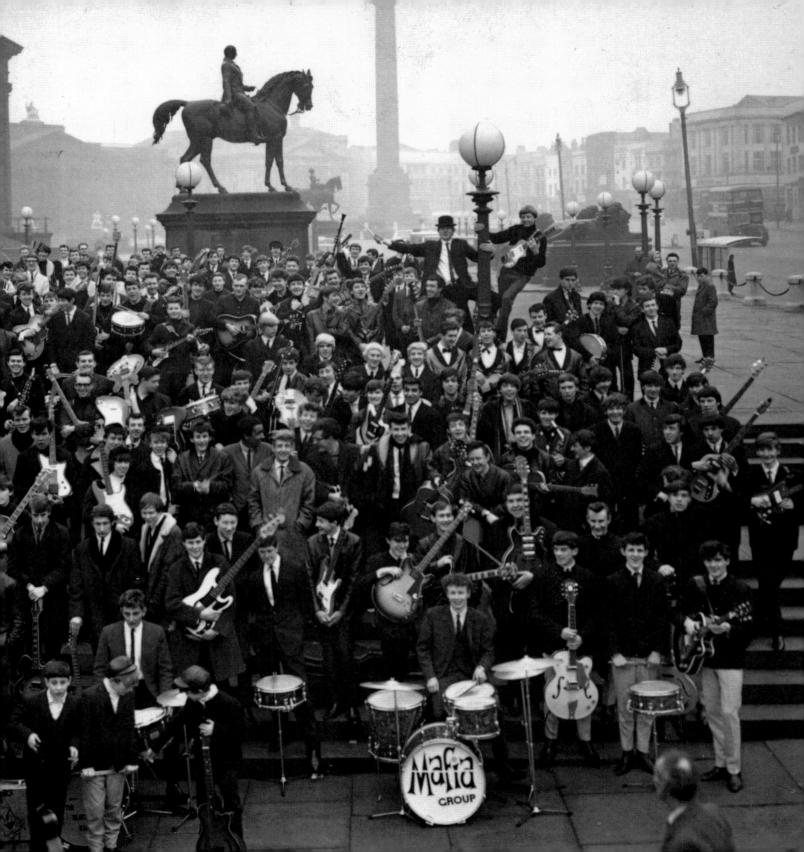

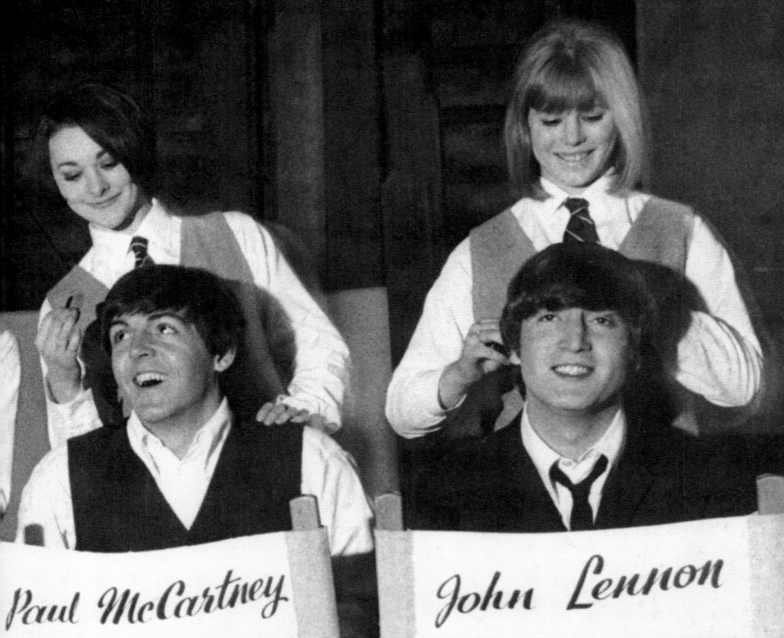

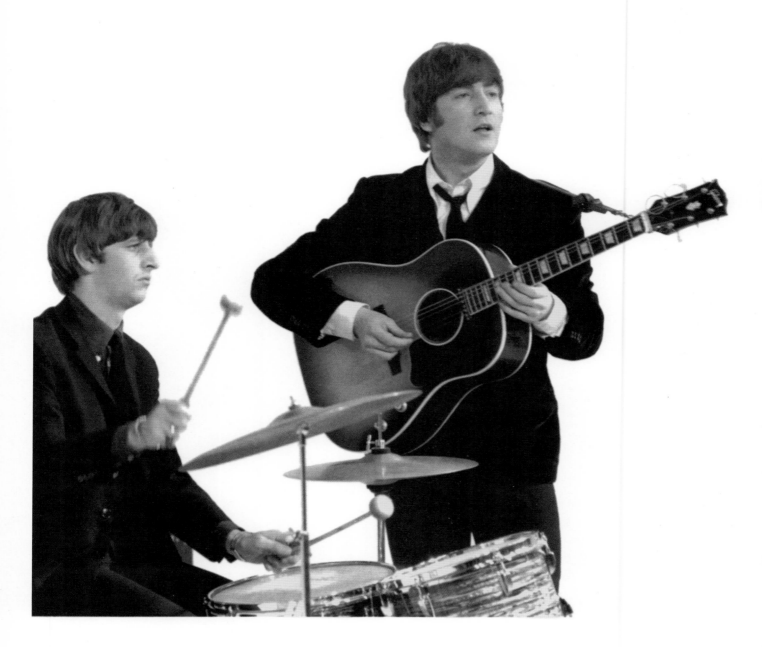

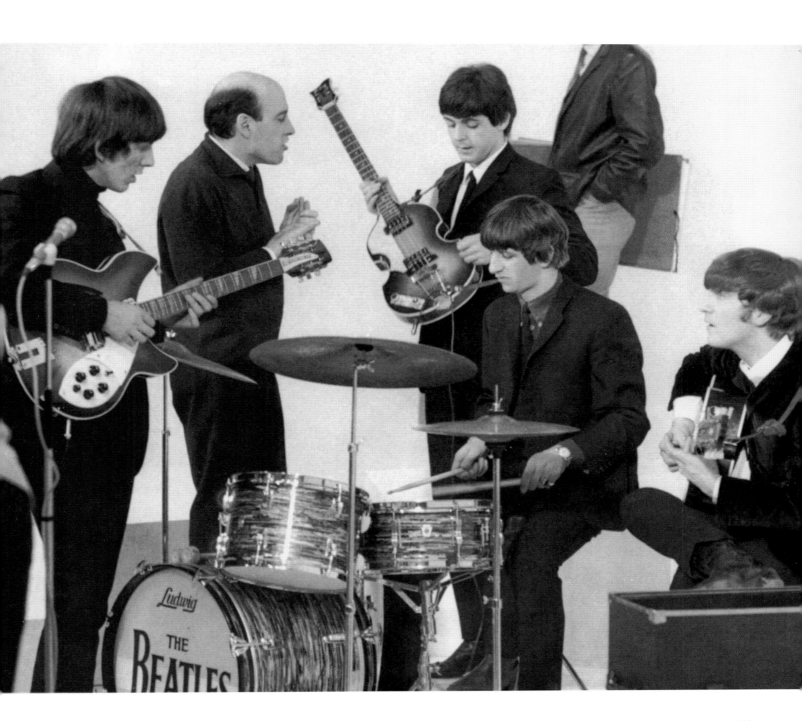

159

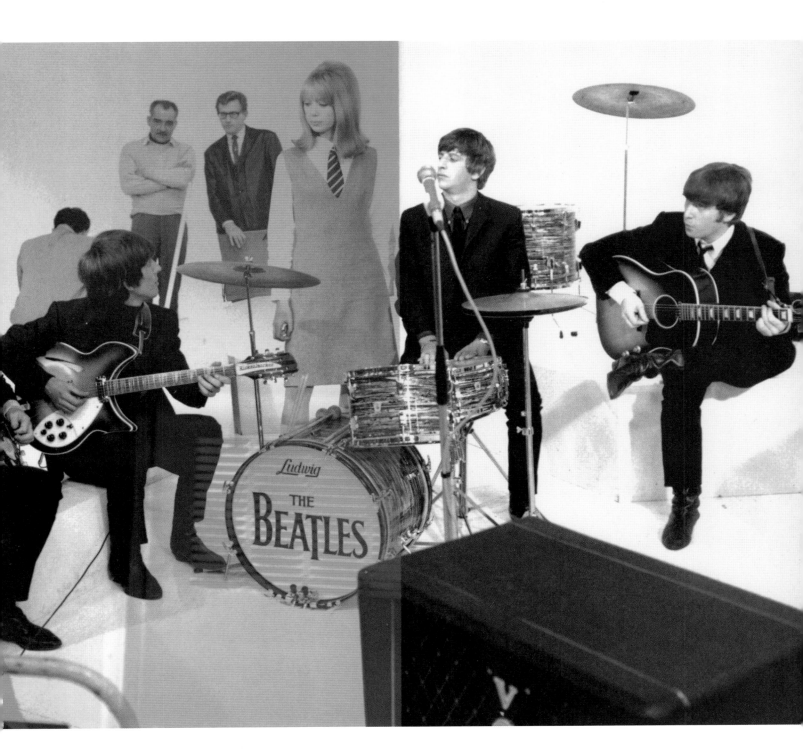

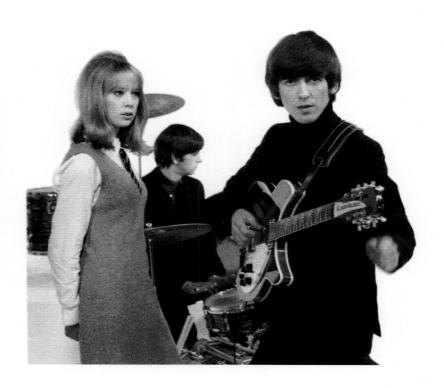

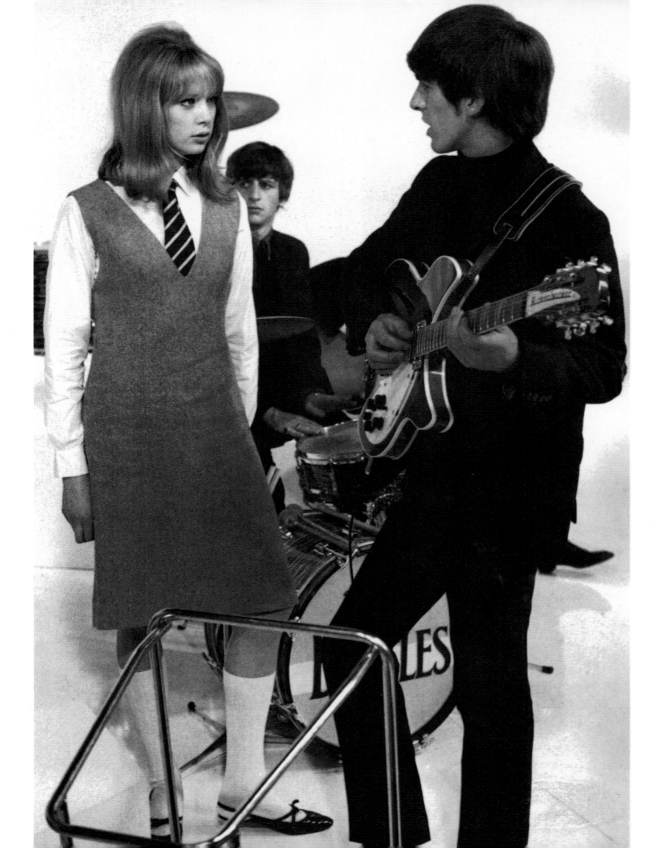

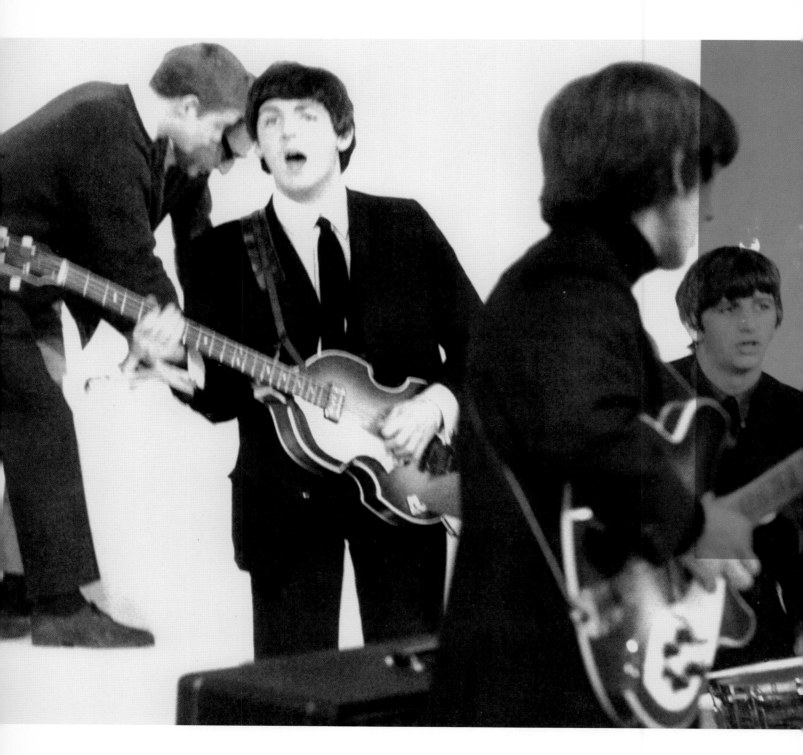

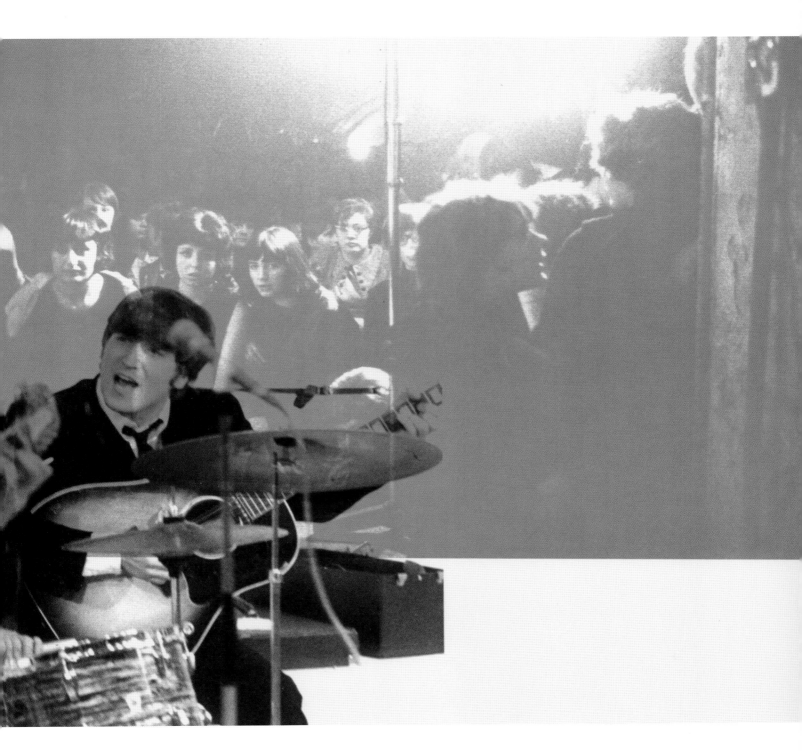

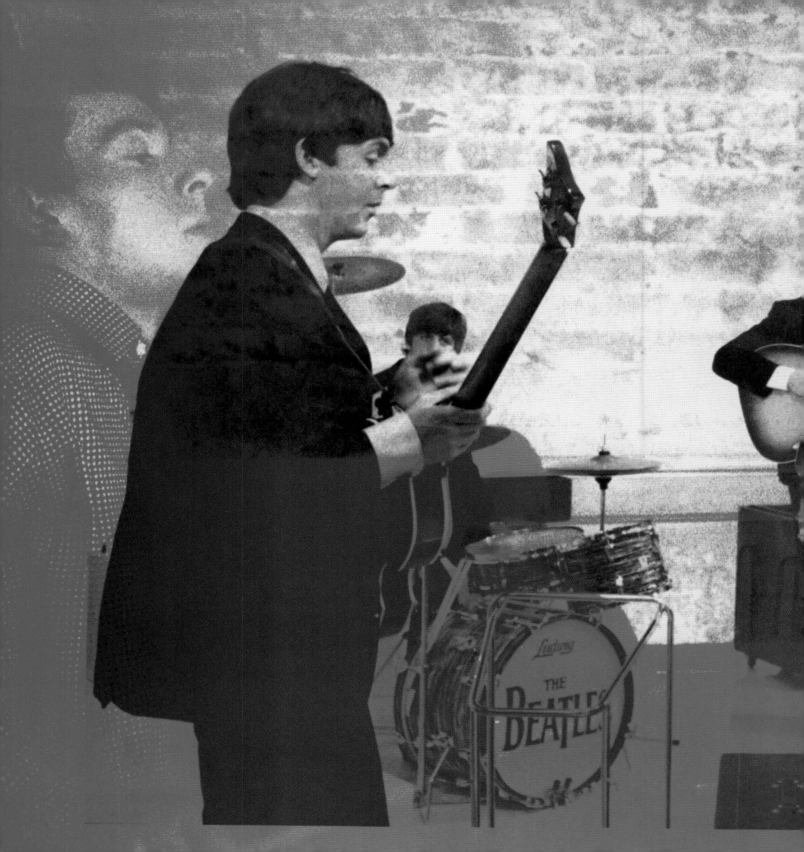

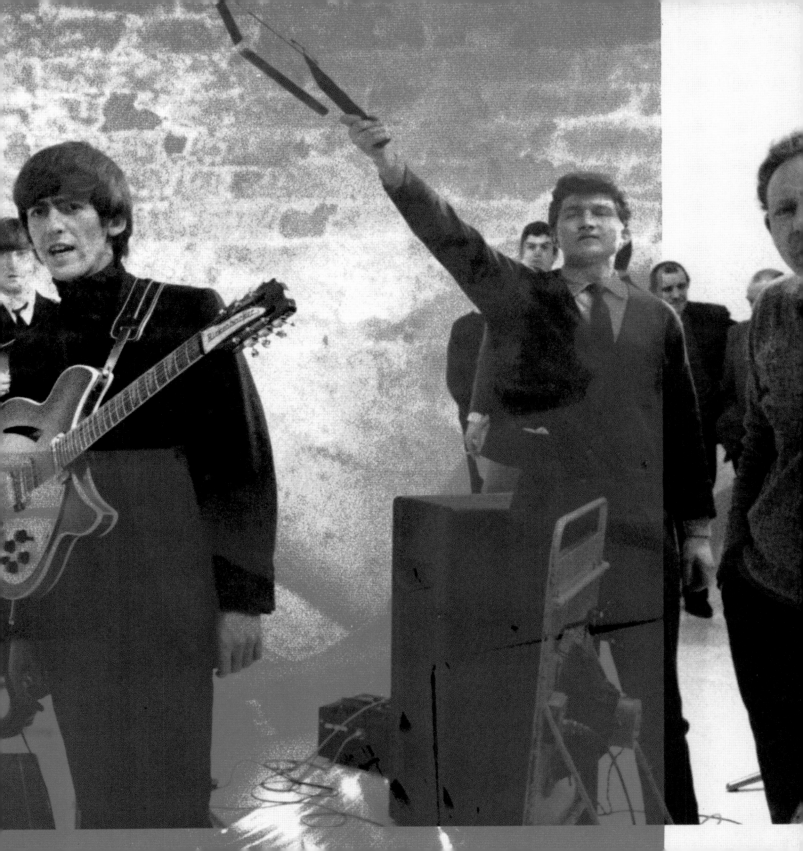

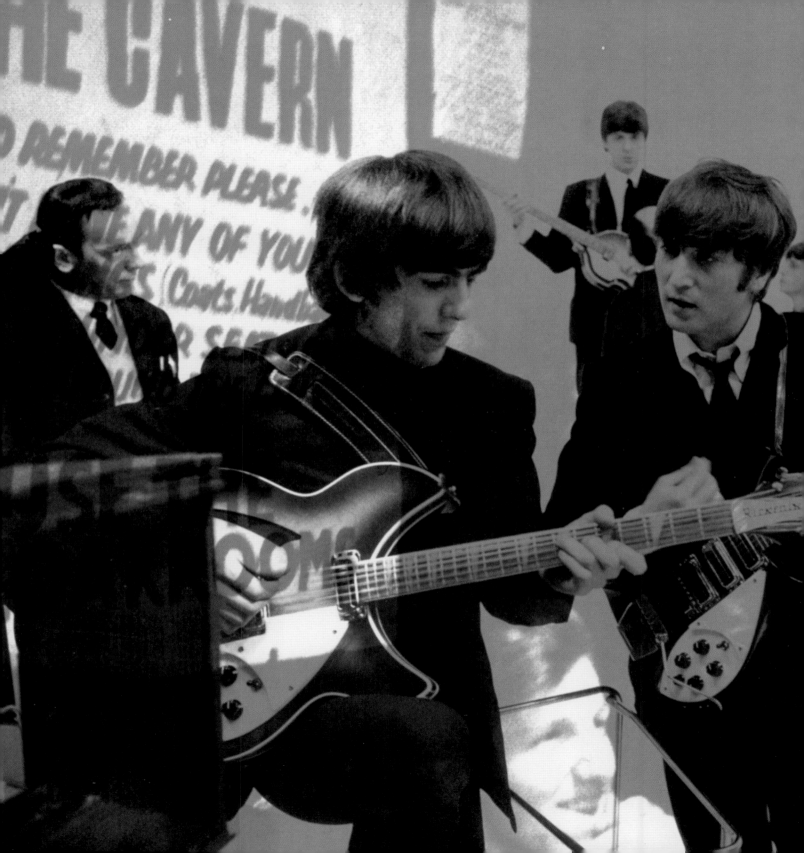

169

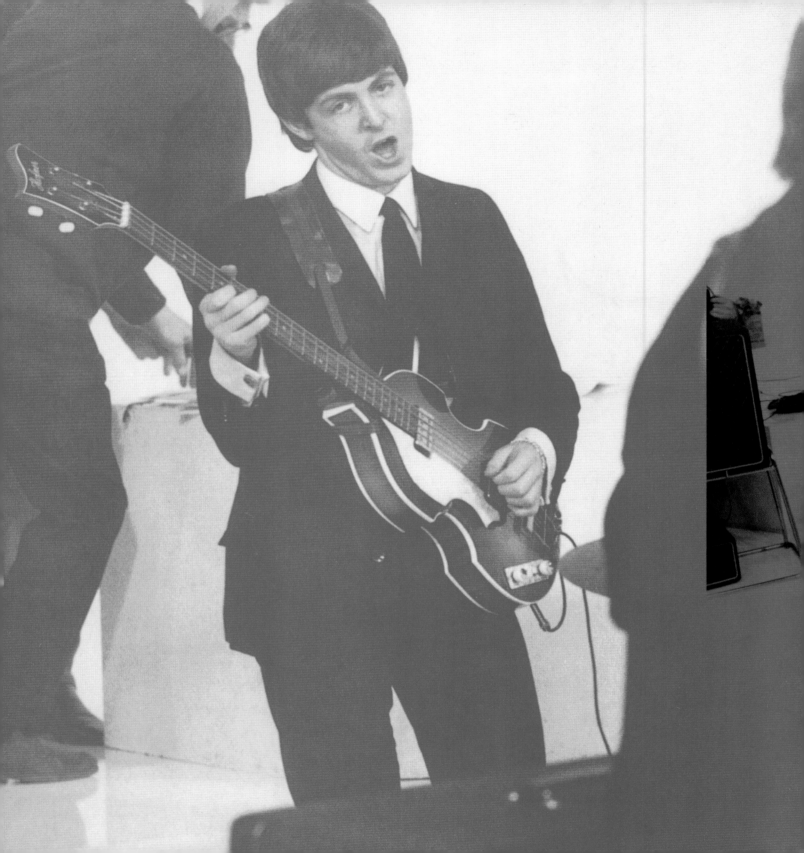

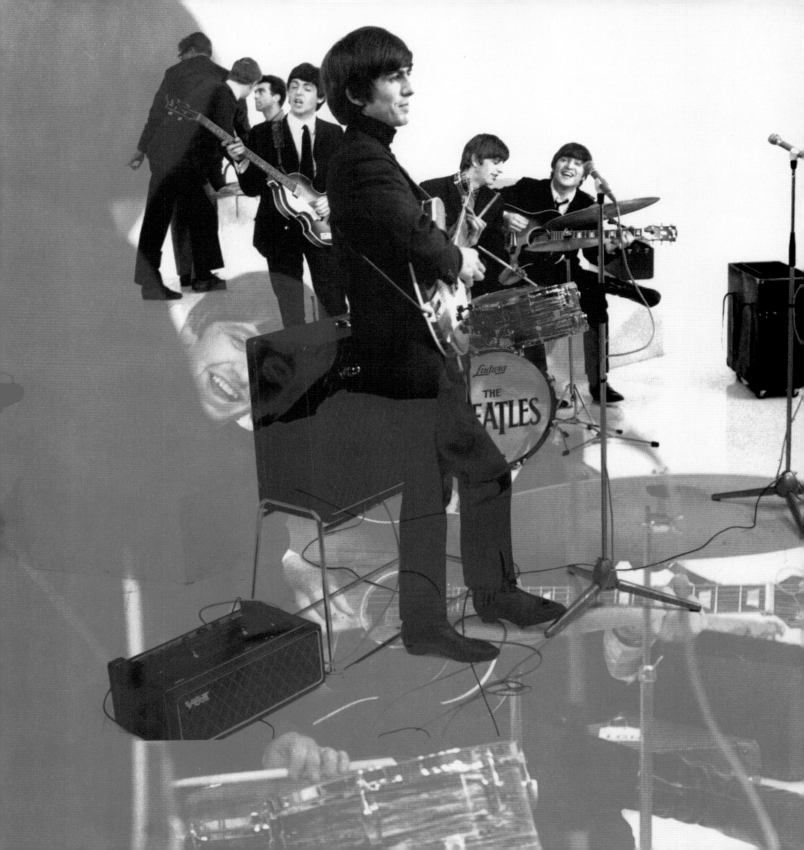

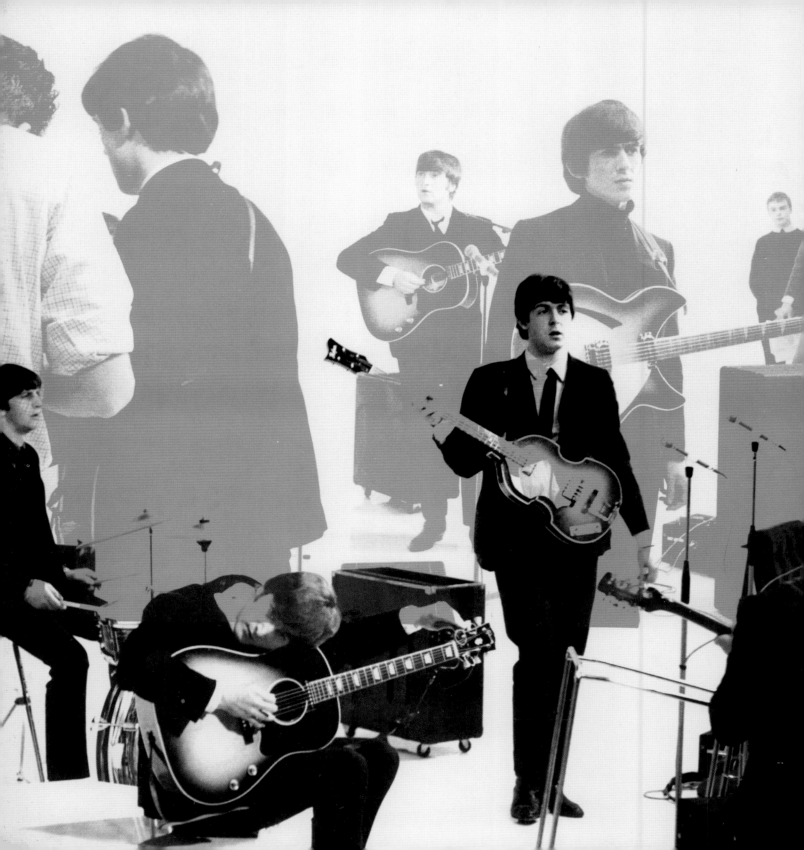

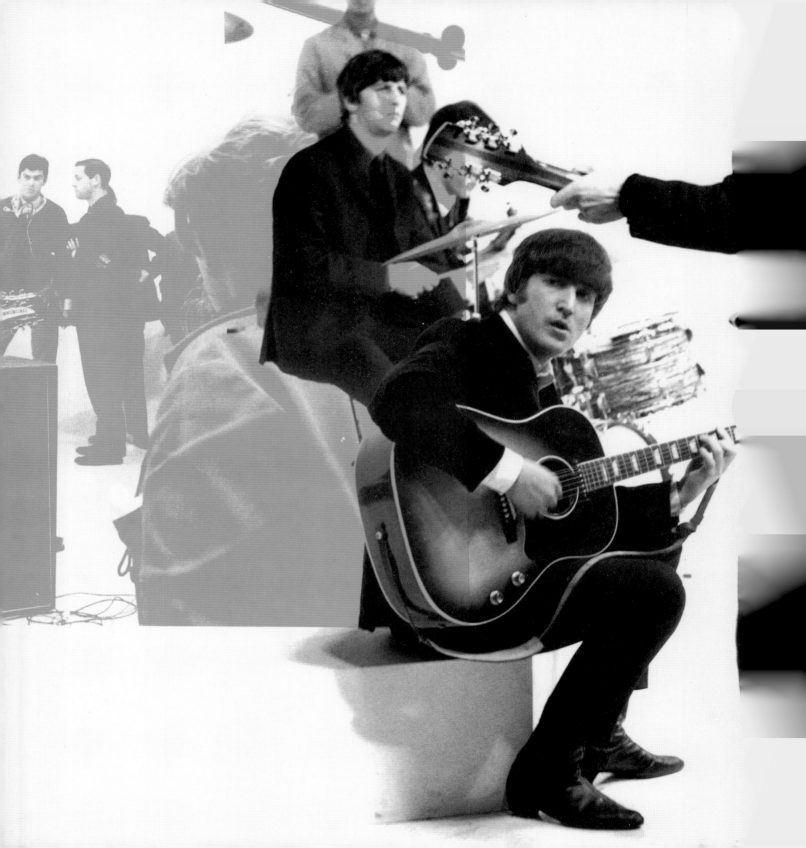

LIST OF PHOTOGRAPHS

After reading Max Scheler's Introduction and Astrid Kirchherr's Foreword, the reader will find that many of the photographs in this book need no further explanation. However, the following may prove useful:

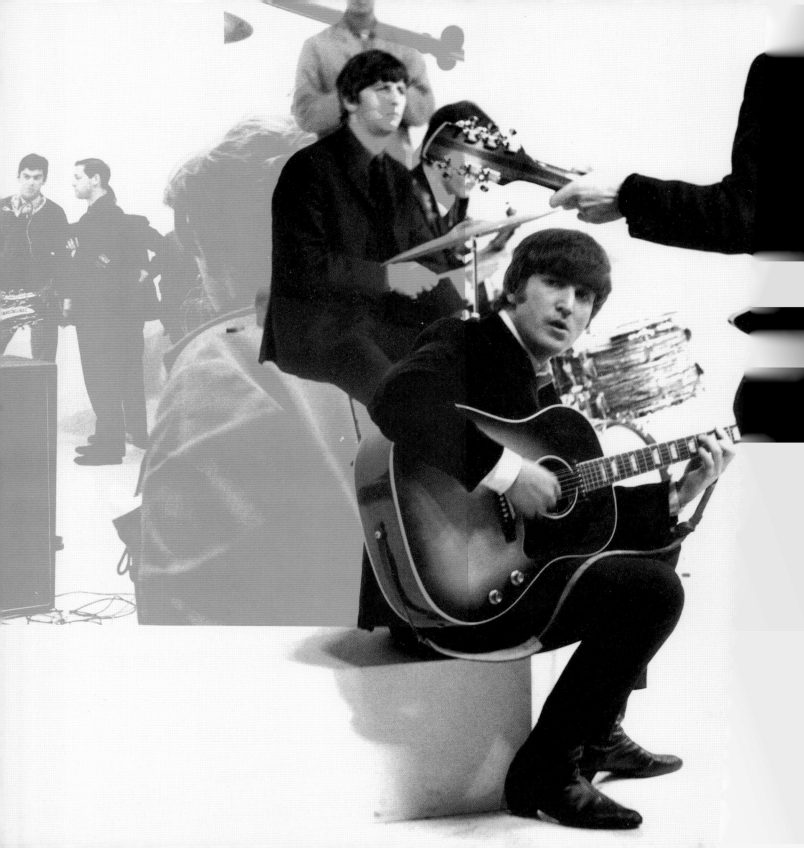

LIST OF PHOTOGRAPHS

After reading Max Scheler's Introduction and Astrid Kirchherr's Foreword, the reader will find that many of the photographs in this book need no further explanation. However, the following may prove useful:

PAGES 14-35: GEORGE AND RINGO'S GREEN STREET FLAT; JOHN AND CYNTHIA'S LONDON APARTMENT.

PAGES 36-59: BEATLES ON SET FOR THE FILMING OF *A HARD DAY'S NIGHT*.

PAGES 60-85: LIVERPOOL IN THE BEATLES' WAKE.

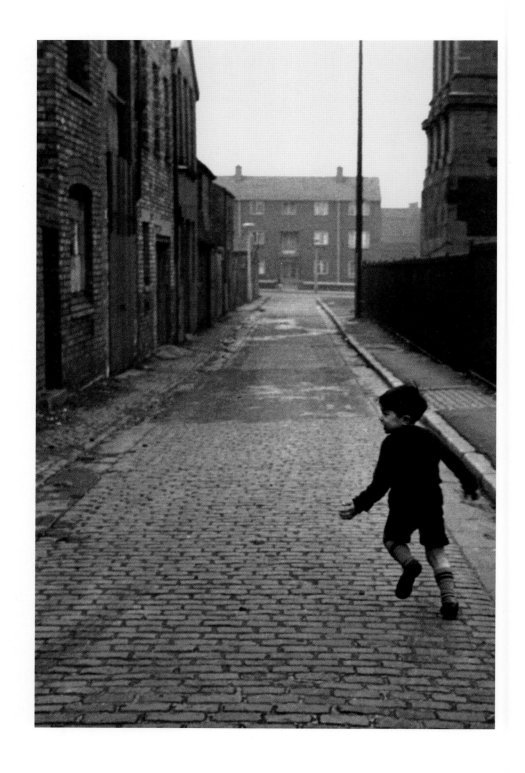

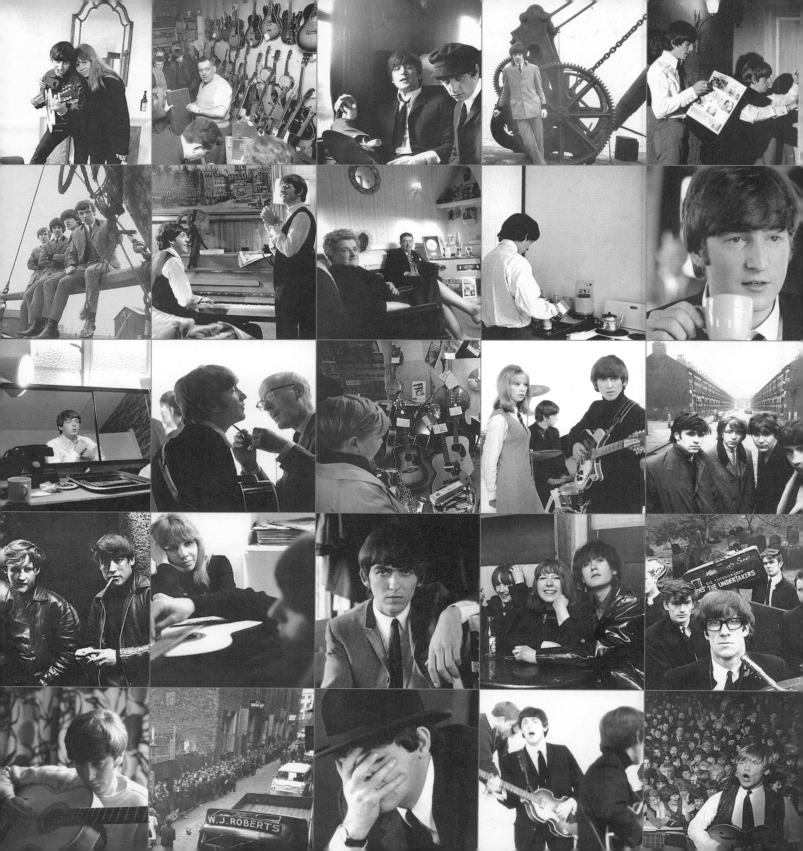